THE OFFICIAL
COOKBOOK

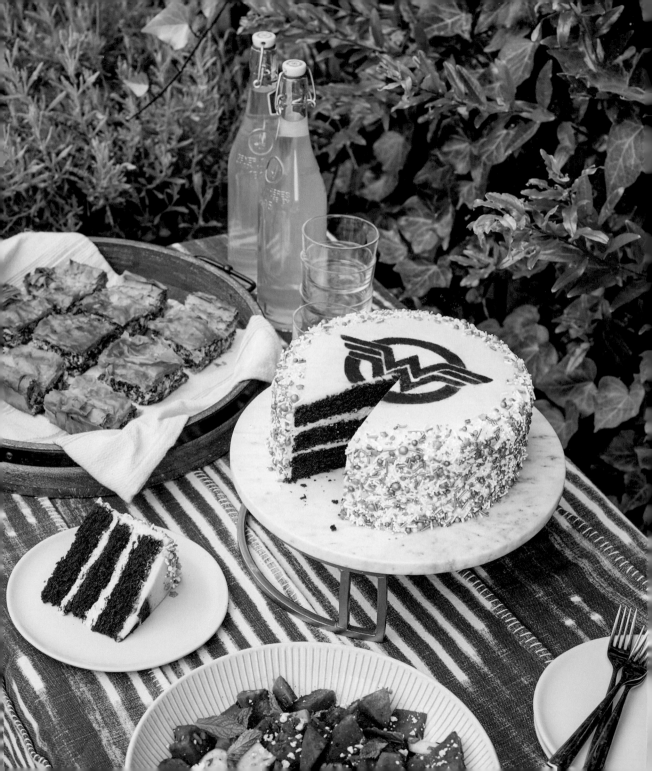

WONDER WOMAN

THE OFFICIAL
COOKBOOK

OVER FIFTY RECIPES INSPIRED BY
DC'S ICONIC SUPER HERO

WRITTEN BY BRIANA VOLK

PHOTOGRAPHY BY CARLA CHOY

WONDER WOMAN CREATED BY WILLIAM MOULTON MARSTON

INSIGHT
EDITIONS

SAN RAFAEL • LOS ANGELES • LONDON

CONTENTS

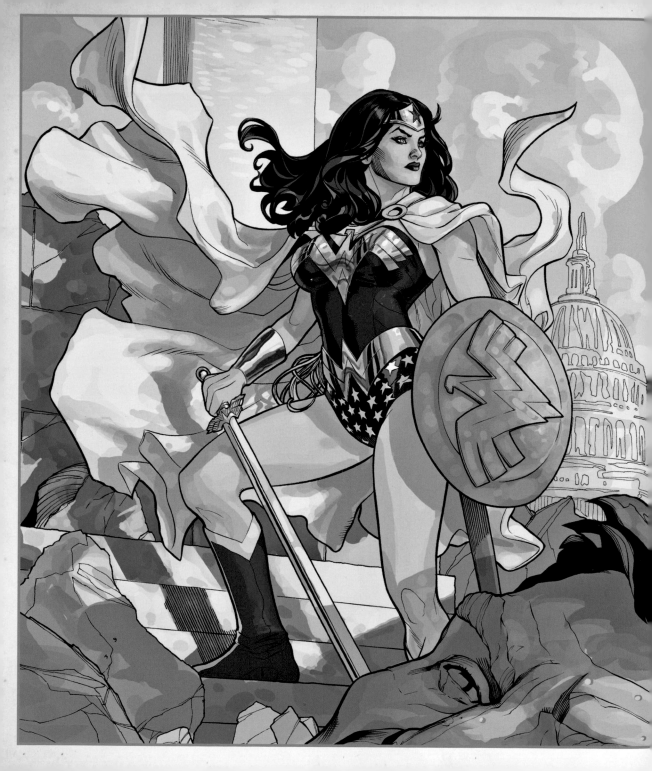

INTRODUCTION: COOKING FOR CHAMPIONS

From the moment Wonder Woman burst onto the pages of *Sensation Comics #1*, she became an icon. Her strength combined with her compassion, intelligence, and advocacy for peace made her a unique hero among her comics compatriots . . . not to mention an unbeatable match for any foe she encountered. Whether you are a passionate follower of Wonder Woman in the pages of comics, remember her on TV, or have recently met her on the big screen, *Wonder Woman: The Official Cookbook* is made for *you*.

The daughter of Hippolyta, the Queen of the Amazons, Diana was born and raised on the island of Themyscira, also known as Paradise Island. While her exact origin story has changed and expanded over the years, the look, feel, and general culture of Themyscira and the Amazons have always retained a strong Greek and Mediterranean influence. To honor this heritage, most of the recipes in this book take their main inspiration from various Mediterranean cuisines. Diana is a world traveler, and so her gastronomic influences range far and wide, but their heart and soul is in classic Greek ingredients: tomatoes, feta cheese, olive oil, honey. The dishes in this book make full use of these strong flavors with simple techniques to keep the recipes accessible to cooks of all levels. And while each recipe is flexible enough to be altered for your individual tastes and diet, in honor of the fact that one of Diana's powers is empathy for animals, all the recipes in this book are vegetarian.

Light, healthy, flavorful, these recipes will take you from your kitchen straight to Paradise Island. Expect big and bold flavors to help increase your strength and power no matter what challenges you may face—including deciding what to make for dinner. Whether cooking for yourself, a busy family, or a big dinner party, these hearty breakfasts, elegant entrées, and dainty desserts are sure to keep the whole league full, happy, and ready for the next battle.

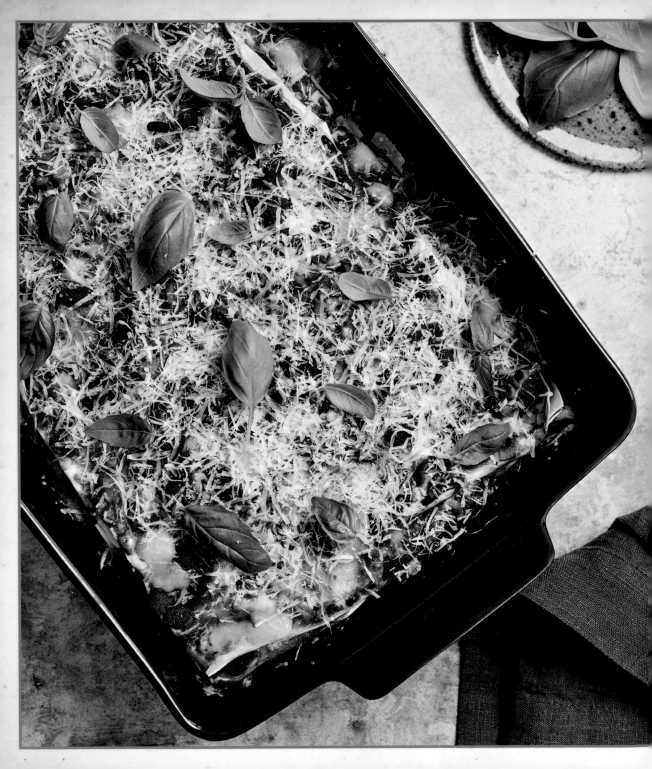

A WARRIOR'S GUIDE TO BASIC PANTRY ESSENTIALS, TOOLS, AND TERMINOLOGY

AL DENTE ★★★ Directly translated, it means "to the teeth." This means cooking your pasta so it is not completely soft but has a little "bite" to it. This is especially important when pre-cooking pasta before baking it.

BEAT ★★★ To whisk briskly in a bowl. This can also be done using a hand mixer or a stand mixer and is mostly used for combining eggs.

CHOP ★★★ To cut food into bite-size pieces with a knife. A rough chop can be larger and more uneven.

CUBE ★★★ To cube butter, cut a cold stick of butter in half, lengthwise. Then, cut those halves in half lengthwise again. Starting at the short ends, cut the butter into ½-inch segments. Repeat as needed for the recipe.

CUT IN BUTTER ★★★ Combine butter and flour in a large bowl, and then use your fingers to pinch and rub the two together until the dough gains a wet sand–like consistency. The goal is to get pea-size pieces of butter mixed into the flour, which will create air pockets, which in turn creates a light and airy dough. Be careful not to overmix the butter because you do still want cool chunks. If the butter melts, the air pockets won't form.

DICE ★★★ To cut foods into very small and evenly sized pieces for cooking.

DRIZZLE ★★★ This is a very slow, thin stream of liquid such as olive oil or melted butter. The object is for either decorative purposes or to add flavor.

FOLD ★★★ Folding is the process of gently combining ingredients without mixing or stirring. Use a spatula to lift and turn the mixture until the ingredients are combined.

ICE BATH ★ ★ ★ An ice bath is used to stop something from cooking very quickly. Take a bowl and fill halfway with ice, and then fill the rest with water. The most common use for an ice bath is for boiled eggs, which are transferred directly from the pot to the bath to stop them from cooking.

KNEAD ★ ★ ★ Kneading is working the dough so the glutens in the flour develop and give the dough the right structure and texture. You can knead two ways: by hand on a hard surface or with a mixer that has a dough hook.

PASTRY RINGS ★ ★ ★ These metal rings come in an assortment of sizes and are easily found at cooking stores and major online retailers. When used in baking and cooking, a pastry ring's job is to hold the pastry as it is baking, helping it to keep your desired shape and size.

SAUTÉ ★ ★ ★ This technique refers to cooking food in a pan on the stove briefly over a high heat, usually in a fat such as oil or butter.

SHAGGY DOUGH ★ ★ ★ A loose dough that is lumpy and has no dry spots.

SHIMMERING OIL ★ ★ ★ When oil is cool in a pan, it will generally look smooth. Bringing oil to a shimmer means heating it until it glistens but not to the point that it looks slightly wavy and moves around a little.

SIMMER ★ ★ ★ A simmer is a gentle boil. This keeps food from cooking too quickly and doesn't disturb the ingredients as much as a full boil.

SLICE ★ ★ ★ To cut ingredients, like vegetables, into evenly sized and shaped pieces. When you make everything the same size, it cooks more evenly.

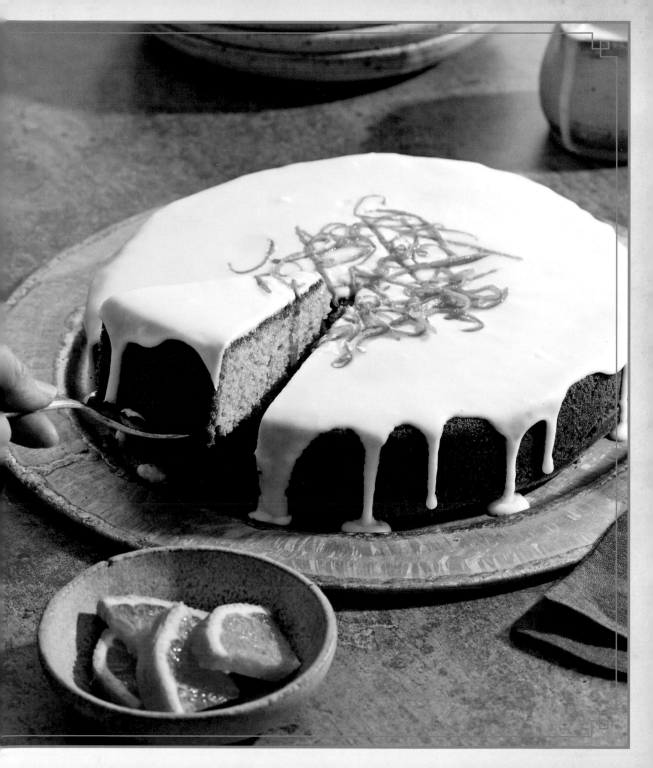

BATTLE-READY
Breakfasts

.

Breakfast is the most important meal of the day, whether that day includes an algebra test, a midmorning meeting with your boss, or a deadly showdown with the Cheetah. This chapter includes a variety of morning meals, from light and healthy breakfast bowls to full and hearty plates for fueling the fighter inside. It even includes a few indulgent brunch treats. After all, who says superheroes can't enjoy bread pudding for breakfast occasionally?

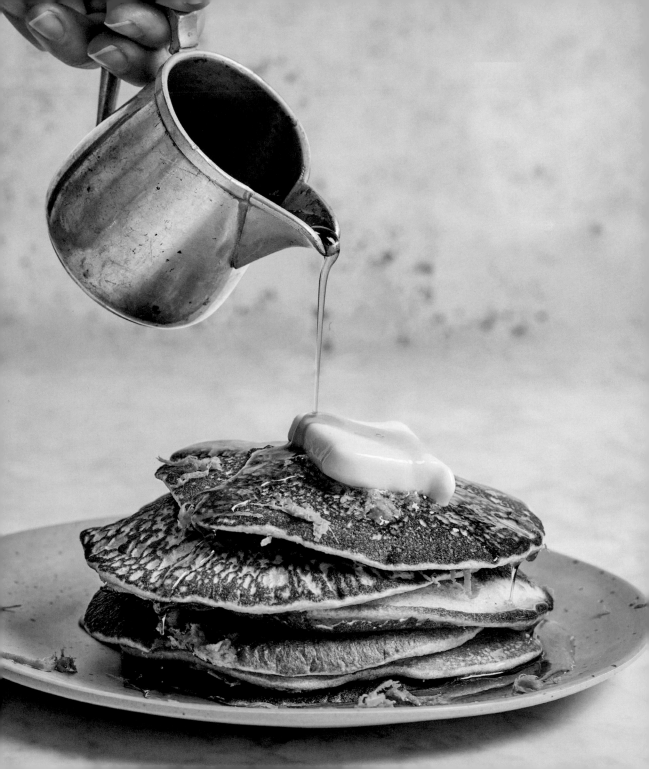

Paradise Island Pancakes

These are twice as fluffy as any you'll find in the mortal world. Top a heaping mountain of them with fresh berries, whipped cream, maple syrup, or whatever your favorite pancake topping might be—you can't go wrong.

2 eggs yolks

5 tablespoons packed light brown sugar, divided

2 teaspoons vanilla extract

1 teaspoon baking powder

6 tablespoons cake flour

¼ cup whole milk

5 egg whites

1 teaspoon orange juice, plus zest, for garnish

½ teaspoon salt

Unsalted butter, for coating pan and serving

TIP:
NO CAKE FLOUR? ALL-PURPOSE FLOUR WILL WORK ALMOST AS WELL, THOUGH THE PANCAKES MAY NOT BE AS FLUFFY.

1. Preheat the oven to 200°F. Combine egg yolks, 1 tablespoon brown sugar, vanilla extract, and baking powder in a large bowl. Whisk until well blended. Add the flour and milk, whisking until the batter is fully combined, with no dry flour bits present, about 1 minute.

2. In a separate bowl, combine the egg whites and orange juice. Using a hand mixer on medium-high speed, whisk the mixture until the egg whites are foamy, about 4 minutes. Slowly add the salt and remaining brown sugar while continuing to whisk. Turn the speed to high, and whisk until you get a glossy meringue with stiff peaks, about 6 minutes.

3. Using a spatula or wooden spoon, gently fold the meringue into the batter until no streaks remain in the mixture.

4. Warm a nonstick skillet over low heat. Add a pad of unsalted butter, and let it melt. Place a pastry ring (see A Warrior's Guide to Basic Pantry Essentials, Tools, and Terminology, page 10) in the center of the warm skillet. Pour ¼ cup of the batter into the ring on the skillet. Place a lid on the skillet, and let the pancake cook for 3 to 4 minutes, until it has risen like a soufflé. Flip the pancake, and cook the other side for another 2 minutes. Remove the pancake from the skillet, and repeat until the rest of the batter is gone. Keep the finished pancakes warm on a plate in the oven.

5. Top the pancakes with your choice of maple syrup, butter, orange zest, or other topings, and serve.

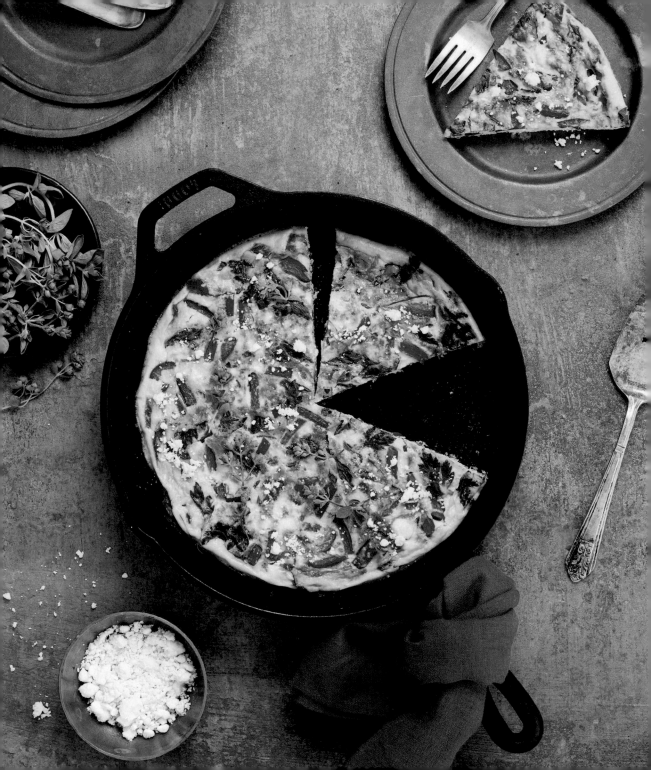

The Amazonian Frittata

The Amazons train for hours a day to make their bodies strong—the kind of training that takes more than a banana to get through. This rich frittata is so simple to make but is packed full of flavor and powerful enough to fuel you all day long.

2 tablespoons extra-virgin olive oil, divided

4 red peppers, sliced

2 cloves garlic, chopped or crushed

10 large eggs

4 tablespoons whole milk or cream

Salt and black pepper

1 cup feta cheese, drained and crumbled

2 tablespoons fresh oregano leaves, chopped

1. Preheat the broiler, setting the rack on the highest position in the oven.

2. Heat 1 tablespoon of extra-virgin olive oil in a large nonstick, oven-proof skillet over medium heat. Add the sliced red pepper and cook for 2 minutes. Add the garlic and cook for another 2 minutes. Turn off the heat, transfer the pepper mixture to a bowl, and set aside. Return the skillet to the stove.

3. In a large bowl, whisk the eggs, milk, and salt and pepper to taste. Add the remaining 1 tablespoon of olive oil to the skillet and heat over medium until the oil is just shimmering. Add the egg mixture to the pan, and then add the peppers and top with the crumbled feta. Cover the pan and cook for about 10 minutes, gently agitating the pan throughout cooking.

4. Once the frittata is nicely set, remove from the stovetop and place under the broiler uncovered. Broil the frittata until it is a nice golden brown, about 1 to 3 minutes. Remove from the oven, and let cool for about 10 minutes. Garnish with fresh oregano leaves. Slice and serve.

Themyscira Overnight Oats

A light, nutritious dish bursting with flavor, this breakfast will help even the littlest superhero shine as bright as a morning on Themyscira.

1 cup rolled oats (not instant)

½ cup dried cherries, apricots, and apples, cut into small pieces

3 tablespoons pumpkin seeds

2 cups milk of your choice

½ teaspoon salt

Honey and brown sugar, to serve

1. Combine the oats, dried fruit, pumpkin seeds, milk, and salt in an airtight container. Refrigerate for at least 6 hours or up to 4 days.

2. Uncover, stir, and top with honey and brown sugar.

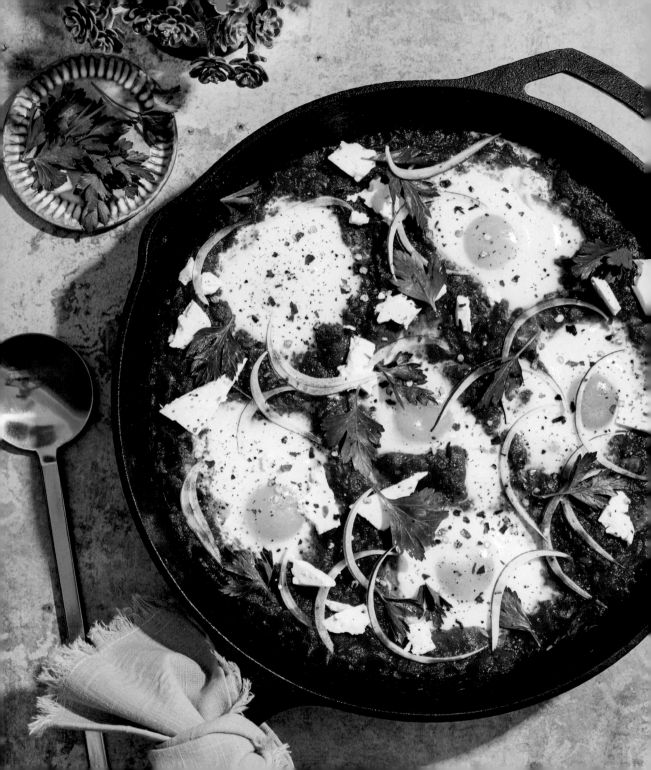

Cassandra Sandsmark's Shakshuka

★ ★ ★ ★ ★ YIELD: 6 SERVINGS ★ ★ ★ ★ ★

For a bright and spicy start (or end) to the day, this shakshuka—inspired by Cassandra Sandsmark, also known as Wonder Girl, and her world travels— will hit the spot. When you are ready to embrace your own superpowers, like Cassie has, this is where you start—no magical artifacts required. Just a healthy serving of her shakshuka!

4 tablespoons extra-virgin olive oil

1 red onion, thinly sliced

2 red bell peppers, thinly sliced and seeds removed

1 green bell pepper, thinly sliced and seeds removed

4 cloves garlic, chopped or crushed

1 teaspoon cumin

½ teaspoon cayenne or Aleppo pepper

½ teaspoon chipotle powder

½ teaspoon paprika

One 28-ounce can whole plum tomatoes

Salt and fresh ground black pepper

1½ cups feta cheese, drained and crumbled

6 large eggs

Fresh flat-leaf parsley

1. Preheat the oven to 375°F.

2. Heat the oil in a large oven-safe skillet over medium heat. Add the onion and bell peppers, cooking them until they become soft, about 4 minutes. Add the garlic, and cook for another 1 to 2 minutes.

3. Add the cumin, cayenne (or Aleppo) pepper, chipotle powder, and paprika, stirring to make sure the vegetables are evenly covered in the spices. Use a spoon to gently crush the whole tomatoes in the can before pouring into the skillet. Season with salt and pepper to taste, adding more cayenne if you'd like a spicier dish.

4. Bring tomatoes to a simmer. Allow the tomatoes to simmer, uncovered, for 10 minutes, or until the mixture has thickened. Add the crumbled feta.

5. Crack the eggs directly onto the tomato stew, and sprinkle with salt to taste. Place the whole skillet in the oven, and cook until the egg whites are set, about 4 minutes. Remove from the oven, and garnish with parsley leaves. Serve with thick-sliced bread.

Daughter of Zeus Breakfast Bowl

★ ★ ★ ★ ★ YIELD: 4 SERVINGS ★ ★ ★ ★ ★

Start your day with this hearty meal that has grains, greens, and an egg—perfect for those with a godlike appetite. Protein-rich with an eye-opening dressing (feta, garlic, pepper, and extra-virgin olive oil), even Zeus can't beat this energy-packed breakfast.

FOR THE
BREAKFAST BOWL:

4 large eggs

2 cups cooked quinoa

1 cup shredded Romaine lettuce

2 ripe avocados, sliced

½ cup alfalfa sprouts

½ cup chopped tomato

FOR THE DRESSING:

¼ cup extra-virgin olive oil

1 clove garlic, chopped or crushed

1 cup feta cheese, drained and crumbled

Black pepper

¼ cup fresh-squeezed lemon juice

1. Bring a medium pot of water to a boil. Place eggs into the water, and cook for 6 minutes, until soft-boiled. When the eggs are done, remove from the water and place into an ice bath to halt cooking. Once cooled, peel the eggs.

2. In a small skillet over medium heat, heat 1 teaspoon of extra-virgin olive oil and cook the crushed garlic until it is aromatic, about 1 minute. Add garlic to a food processor or blender along with the feta, pepper, and lemon juice. Blend until dressing is smooth and creamy, adding olive oil until the dressing is a consistency you prefer. Add more pepper to taste.

3. In individual bowls, evenly portion the quinoa, then layer the lettuce, avocado, sprouts, and tomato. Drizzle dressing on top. Add a cooked egg to each bowl on top of the salad, and slice each in half so the yolk spills out and combines with the dressing. Serve immediately.

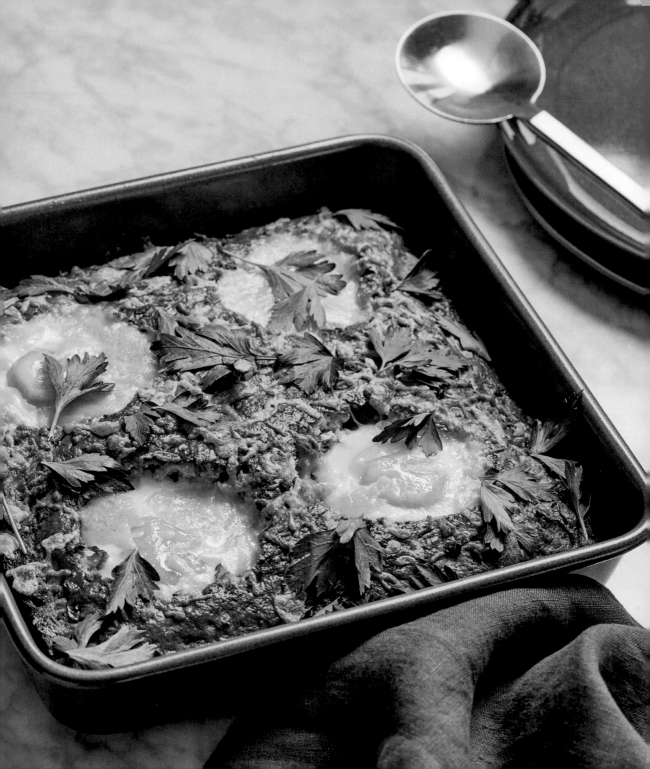

A Warrior's Cornbread Breakfast

★ ★ ★ ★ ★ YIELD: 4 SERVINGS ★ ★ ★ ★ ★

Every hero needs a strong start to the day before facing school, work, or Ares. Filled with hearty and healthy kale, topped with baked eggs, and surrounded by fresh, toasty cornbread, this dish will ensure you're ready to face anything your day throws at you.

1 box cornbread mix plus ingredients listed on the box

4 tablespoons unsalted butter, divided

1 large bunch kale

Salt and black pepper

½ cup shredded cheddar cheese

4 large eggs

Fresh parsley, for garnish

1. Preheat the oven to 375°F. Prepare the cornbread mix according to the directions on the box. Using 2 tablespoons of butter, grease a 9-by-9-inch baking dish.

2. In a large skillet over medium-high heat, melt 2 tablespoons of butter. Add the kale, and cook until it is soft, about 3 minutes. Season with salt and pepper to taste. Remove the kale from the pan, and drain until there is no excess liquid. Stir kale into the cornbread mixture, making sure you have an even distribution of greens throughout.

3. Add the mixture to the greased baking dish, and place in the oven, baking according to the directions on the cornbread mix box, approximately 20 to 25 minutes. Five minutes before the cornbread is done, remove the pan from the oven and sprinkle the cheddar cheese on top. Crack each egg whole on top of the cheese, making sure they're spread evenly over the cornbread. Return to the oven to finish baking, approximately 5 more minutes.

4. Remove baking dish from oven, slice, and serve warm.

Fruit of the Gods Muffins

★ ★ ★ ★ ★ YIELD: 12 SERVINGS ★ ★ ★ ★ ★

Even the gods know that figs are just otherworldly. These muffins let the figs be the star of the show from beginning to end. Turn these into a dessert by topping with pearl sugar or honey—making them a heavenly treat for all.

2½ cups all-purpose flour

1 tablespoon baking powder

1 teaspoon ground cinnamon

½ teaspoon ground nutmeg

¼ teaspoon baking soda

¼ teaspoon salt

2 large eggs, lightly beaten

1 cup buttermilk

1 cup light brown sugar, tightly packed

½ cup butter, melted

1 cup dried figs, roughly chopped

1. Preheat the oven to 375°F. Line a muffin tin with liners.

2. In a large bowl, whisk together flour, baking powder, cinnamon, nutmeg, baking soda, and salt. In a separate medium bowl, whisk together eggs, buttermilk, brown sugar, and melted butter. Use a wooden spoon to stir the wet ingredients into the flour mixture until well combined. Add the figs, and stir until incorporated.

3. Using an ice-cream scoop, fill the muffin cups with one scoop of muffin batter. Bake for 30 minutes, or until a toothpick inserted in the center comes out clean.

4. Let cool slightly, and serve warm or at room temperature.

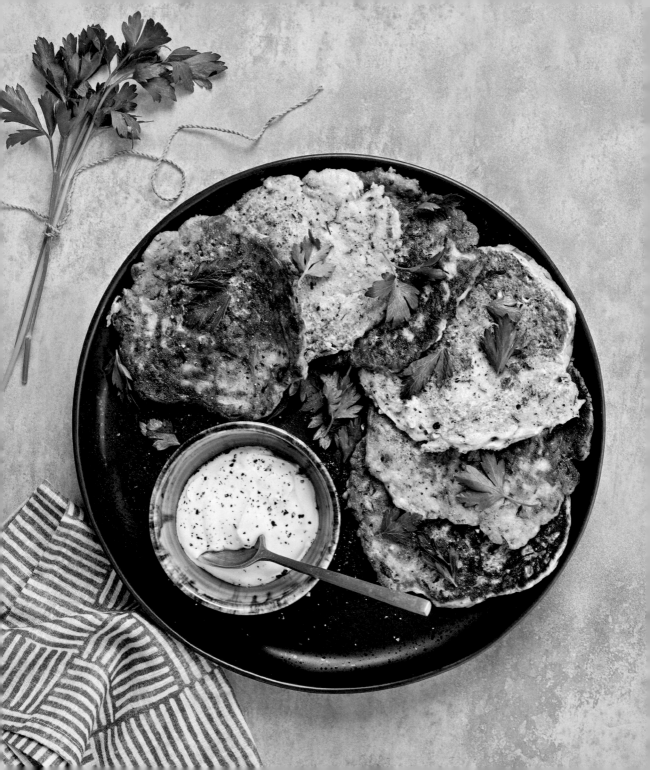

The Oracle Penelope Zucchini Fritters

✳ ✳ ✳ ✳ ✳ YIELD: 4 SERVINGS ✳ ✳ ✳ ✳ ✳

You don't need the gift of prophecy to know that these zucchini fritters topped with a little sour cream and sprinkled with chives will get a hero's welcome every time. They are fun to make and are the perfect balance of sweet zucchini and savory spices.

2 pounds grated zucchini

4 scallions, finely chopped

2 cloves garlic, chopped or crushed

1 cup all-purpose flour

1 teaspoon baking powder

1 teaspoon cumin

1 teaspoon salt

1 teaspoon black pepper

1 teaspoon cayenne or Aleppo pepper

2 large eggs, lightly beaten

½ cup breadcrumbs

Canola oil

Fresh flat-leaf parsley, for garnish

½ cup sour cream

1. In a large bowl, combine the zucchini, scallions, and garlic, and lightly season with salt and pepper. In a separate medium bowl, combine the flour, baking powder, cumin, salt, black pepper, and cayenne (or Aleppo) pepper. Pour the dry mixture onto a sheet tray or large plate with raised sides to create a dredging station.

2. Add the eggs and breadcrumbs to the zucchini mixture, using your hands to mix until everything is well combined. Shape the mixture into flat, 3-inch discs and set aside on a plate for frying. One by one, dredge the fritters in the flour mixture, turning to make sure both sides are evenly coated. Gently shake off excess flour and set aside for frying.

3. Heat canola oil in a skillet or sauté pan over medium-high heat. Add the fritters to the pan in small batches, careful not to overcrowd the pan. Cook for 3 to 4 minutes on each side or until brown. Carefully remove using a slotted spoon so as not to collect any oil.

4. Garnish with parsley, and serve hot with sour cream for dipping.

Hero's Journey Hash

★ ★ ★ ★ ★ YIELD: 6 SERVINGS ★ ★ ★ ★ ★

Wonder Woman's journey has included terrible wars, devastating losses, and multiple apocalypses, yet she has never wavered from her commitment to peace and justice. While Diana's journey started when Steve Trevor arrived on Themyscira, yours is destined to start with this delicious one-pan hash.

2 tablespoons extra-virgin olive oil

1 cup fresh fennel, peeled and sliced

1 cup chopped carrots

2 large potatoes, chopped

2 medium yams, chopped

1 medium red onion, finely chopped

1 teaspoon paprika

1 teaspoon dried oregano

2 tablespoons ketchup

Salt and black pepper

½ lemon, for serving

1. Preheat the oven to 400°F.

2. In a large oven-safe skillet, heat the oil on medium-high until shimmering, and then add all the vegetables. Stir in the paprika, oregano, ketchup, and add salt and pepper to taste. Cook until the vegetables are lightly browned and start to crisp, about 4 minutes, using the back of a spatula to gently press the vegetables into the bottom of the pan to give them a nice crispy crust.

3. Transfer the skillet to the oven, and bake for about 20 minutes, or until the largest pieces are easily pierced by a fork.

4. Remove from the oven and squeeze half a lemon over the hash. Crack pepper on top, and serve.

Fighting-Fit Feta Toast

Feta creamed with lemons brings an unexpected elegance to this simple and light dish. It's the perfect quick breakfast, or midday snack, to get you fueled up for your next training session.

1 cup feta cheese, drained and crumbled

1 tablespoon fresh-squeezed lemon juice

2 teaspoons extra-virgin olive oil

1 tablespoon lemon zest

Salt and black pepper

4 slices thick-cut Italian bread

Fresh mint leaves

1. In the bowl of a food processor or blender, combine the feta, lemon juice, and extra-virgin olive oil, and pulse on medium speed until it is smooth and creamy, about 30 seconds. Add more olive oil if the mixture doesn't seem creamy enough. Transfer to a mixing bowl, add the lemon zest, and mix by hand until fully incorporated. Season with salt and pepper to taste.

2. Toast the bread until it is golden brown. Fill a large zip-top bag with the feta mixture and seal it. Cut one corner of the bag so the mixture can be squeezed out.

3. Squeeze the mixture onto the toasted bread. Garnish with fresh mint, and serve.

Donna Troy Greek Diner Breakfast

★ ★ ★ ★ ★　YIELD: 2 SERVINGS　★ ★ ★ ★ ★

Whether she's preparing to lead the Titans into battle or spend the day relaxing in the world of mortals, the Amazonian warrior Donna Troy is sure to start her day with a full breakfast! This iconic meal includes soft-scrambled eggs with feta, shredded potatoes, and thick-sliced toast, made the same way as they are in traditional Greek diners on the East Coast.

2 large Yukon Gold potatoes, washed and scrubbed

6 tablespoons butter, divided

Salt and black pepper

4 large eggs, lightly beaten

½ cup feta cheese, drained and crumbled

2 slices Italian bread

1. With a box grater, shred the potatoes. Place the shredded potatoes into a medium bowl, and fill with water until potatoes are covered. This will help remove the starches in the potatoes, giving them a better flavor. After 10 minutes, drain the potatoes in a colander, squeezing them against the bottom of the bowl with your hands to get out all the excess liquid.

2. Preheat a nonstick skillet over medium heat, and melt 4 tablespoons of butter in the pan. Once the butter is melted, add the shredded potatoes in an even layer. Salt and pepper the potatoes to taste. Cook the potatoes until a crust forms on the bottom, about 8 minutes. Then, using a spatula, divide the potatoes into portions and flip each one, keeping the potatoes as intact as possible. Once flipped, continue to cook for another 8 minutes. Remove from heat and transfer to plates.

3. Add 2 tablespoons butter to the skillet and melt over medium heat. Pour the eggs into the skillet, and add salt and pepper to taste. Then add the crumbled feta. Slowly swirl the pan so the eggs are constantly in motion, allowing them to blend with the cheese. Using a rubber spatula, lightly flip and stir the eggs to ensure even cooking. When the eggs are soft, turn off the heat. Let them sit in the pan for another minute before transferring to the plate with the potatoes.

4. Toast and butter the bread. Add to the plates and serve.

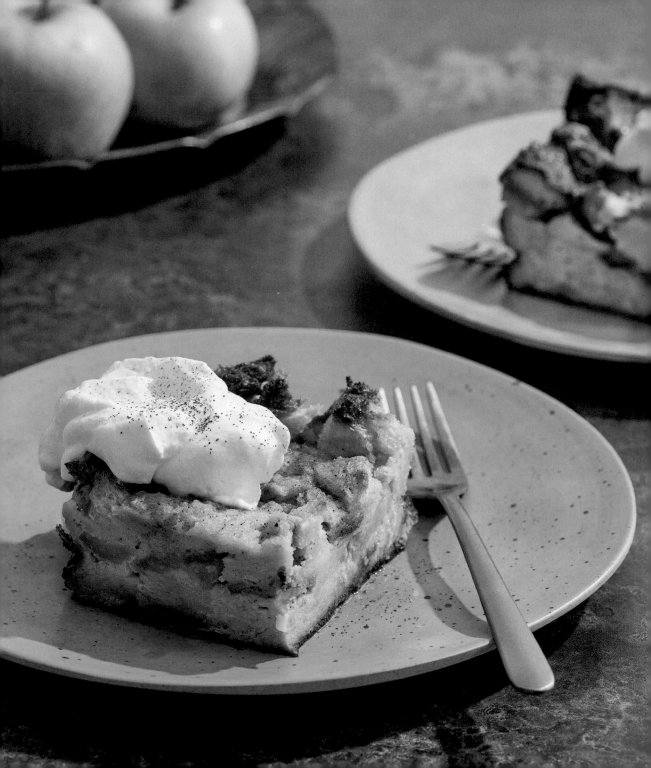

Queen of the Amazons Honey-Apple Bread Pudding

★ ★ ★ ★ ★ YIELD: 10 SERVINGS ★ ★ ★ ★ ★

As regal in presentation as it is rich in flavor, this divine pudding is an excellent centerpiece for any brunch table. Serve with a crown of whipped cream for a sweet breakfast treat worthy of Hippolyta herself!

2 tablespoons unsalted butter

2 to 3 apples, peeled, cored, and sliced into ½-inch slices

⅓ cup light brown sugar

2 cups whole milk

5 large eggs, lightly beaten

¼ cup honey

¼ teaspoon ground cardamom

⅛ teaspoon salt

1 loaf challah bread, torn into large chunks

¼ cup maple syrup

Whipped cream or ice cream, for serving

1. In a skillet, melt the butter on medium heat and add the apples and brown sugar. Cook until the apples are nice and soft, about 4 minutes. Remove the apples from the pan, and let cool to room temperature.

2. In a large mixing bowl, combine the milk, eggs, honey, cardamom, and salt. Cover the bottom of a lightly greased 9-by-9-inch baking dish with a layer of the challah bread and then top with a layer of the cooked apples. Repeat to create two thick layers of bread and apples. Drizzle any leftover juice from the skillet over the top layer.

3. Pour the milk mixture over the apples and bread. Use the back of a spatula to gently press down on the apples and bread, allowing them to get drenched in the mixture. Cover with plastic wrap, and let sit for at least 1 hour, or as long as overnight, so the bread can soak up all the liquid.

4. Preheat the oven to 350°F. Remove the plastic wrap from the baking dish, and bake the pudding for 45 minutes. The pudding should be golden and bubbly. Remove from the oven and drizzle with the maple syrup. Top with whipped cream or ice cream.

AMAZONIAN
Appetizers, Sides, and Snacks

· · · · · · · · ·

Whether you're looking for the perfect sidekick for your main dish, a delicious post-patrol midnight snack, or a selection of appetizers to bring to the next Justice League meeting, you will find something to love in this chapter. From bright and healthy side salads to energizing snacks to some truly divine dips, these small bites are sure to satisfy superheroes big and small.

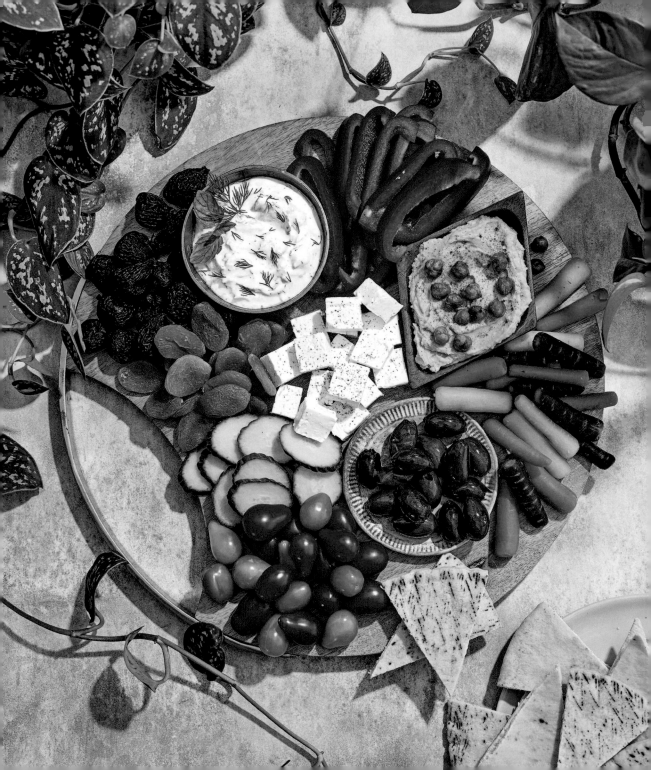

Paradise Platter

Bring all the forces of a tasty, healthy, and beautiful meal together with an impressive vegetarian party platter that everyone on your island will gather around to admire and enjoy.

6 slices pita bread, cut into wedges

1 cup hummus

1 cup tzatziki

1 cup Kalamata olives

2 cups baby carrots

1 English cucumber, sliced

2 red bell peppers, seeded and sliced

2 cups cherry tomatoes

½ cup dried figs

½ cup dried apricots

1 cup feta cheese, drained and cubed

½ cup roasted chickpeas, for garnish

½ cup whole fresh mint leaves, for garnish

1. On a large board, arrange the pita wedges in a large pile. Transfer the dips into decorative serving bowls for serving, and arrange them around the board. Arrange the vegetables, dried fruit, and feta around the board, keeping an eye to color and the even placement of all the items. Garnish your hummus with the roasted chickpeas and the tzatziki with the mint leaves. Step back and enjoy!

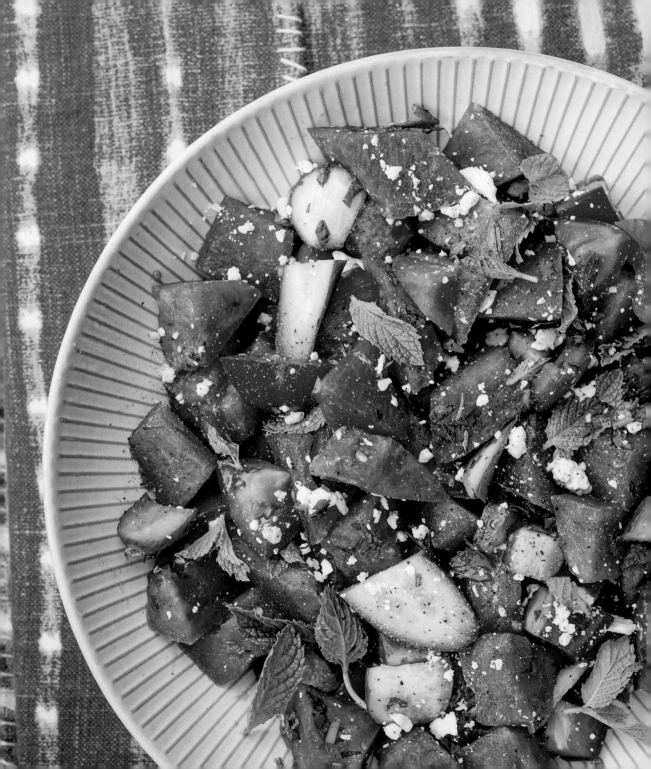

Gift of the Gods Salad

★ ★ ★ ★ ★ YIELD: 4 SERVINGS ★ ★ ★ ★ ★

The Amazons knew that Zeus and the other gods and goddesses bestowed gifts upon them, including this bright salad that mixes savory feta cheese and mint with sweet watermelon in perfect harmony, just like life on Themyscira.

1 medium-size watermelon, cut into 1-inch cubes

2 large tomatoes, chopped

1 English cucumber, chopped

1 shallot, thinly sliced

½ cup Kalamata olives, pitted

1 cup feta cheese, drained and crumbled

3 tablespoons extra-virgin olive oil

1 tablespoon red wine vinegar

½ cup fresh flat-leaf parsley, chopped

½ cup fresh mint, torn

Salt and black pepper, to taste

1. In a large bowl, lightly toss the watermelon, tomatoes, cucumber, shallot, olives, and feta, being careful not to crush the watermelon too much. Add the oil and vinegar, and gently toss to evenly coat.

2. Transfer the salad to serving bowls, and garnish with the parsley and mint. Add salt and pepper to taste.

Phyllo Pastry Stars

★ ★ ★ ★ ★ YIELD: 4 SERVINGS ★ ★ ★ ★ ★

With a demanding career as an iconic Super Hero, Wonder Woman doesn't always have time to make everything from scratch. Using store-bought phyllo dough is a secret way for warriors of all ages to make a quick and tasty meal. Filling the dough with feta and spinach and shaping it into stars—this is an easy and fun-to-make meal.

2 teaspoons extra-virgin olive oil, divided

1 small red onion, chopped

3 fresh sage leaves, chopped

1 cup chopped baby spinach

1 cup crumbled feta cheese

1 teaspoon fresh ground black pepper

1 package phyllo shells, frozen

½ cup walnuts, shelled and chopped

1. Preheat the oven to 350°F.

2. In a medium skillet, heat 1 teaspoon of extra-virgin olive oil over medium. Add the onion, and cook for 2 to 3 minutes. Add the sage, and cook until aromatic, about 2 minutes. Add the baby spinach, and cook until greens are wilted and any excess liquid has evaporated, about 8 minutes.

3. In a medium bowl, combine the feta, black pepper, and remaining 1 teaspoon of extra-virgin olive oil.

4. Arrange the frozen phyllo shells on a baking sheet lined with parchment paper or a silicone mat. Add 1 tablespoon of the onion mixture to each cup, followed by 1 teaspoon of feta. Bake for about 15 minutes, or until the cups are golden and the feta is melted.

5. Remove from the oven, and drizzle with extra-virgin olive oil. Garnish with chopped walnuts, and serve warm.

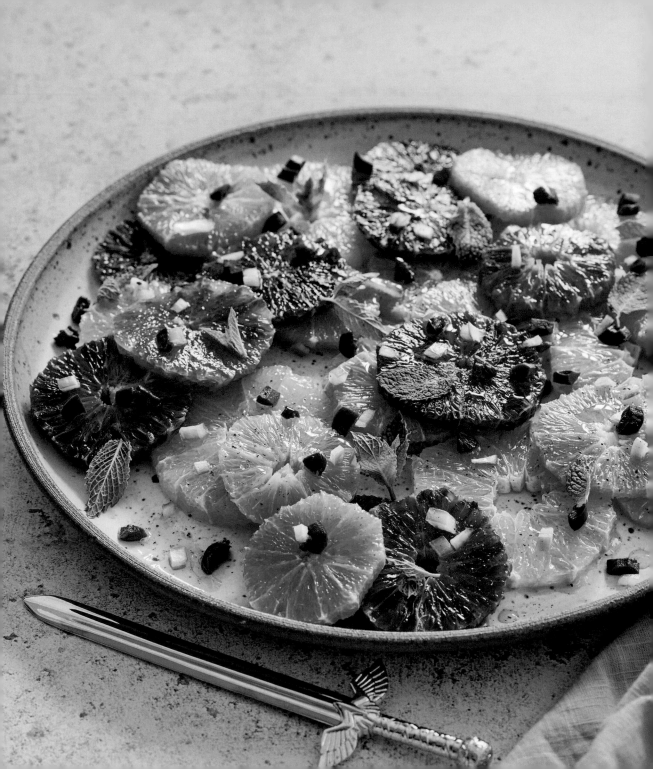

Winter Wonder Fruit Salad

★ ★ ★ ★ ★ YIELD: 4 SERVINGS ★ ★ ★ ★ ★

Bright, bold, and beautiful, this citrus salad turns the bounty of winter into an unforgettable side dish. Keep the Kalamata olives as a garnish so less-adventurous eaters can still enjoy!

FOR THE SALAD:

4 blood oranges

1 large grapefruit

2 navel oranges

1 shallot, finely chopped

Salt

FOR THE DRESSING:

4 tablespoons extra-virgin olive oil

1 teaspoon honey

1 teaspoon apple cider vinegar

Salt and black pepper

½ cup Kalamata olives, pitted and chopped (optional)

Fresh mint leaves, torn into medium-size pieces, for garnish

1. Peel all the citrus and slice into wheels, keeping the thickness as even as possible. Remove any extra seeds. Arrange the citrus on a serving platter, and garnish with the chopped shallot and salt.

2. Whisk the extra-virgin olive oil, honey, and apple cider vinegar in a small bowl. Season with salt and pepper to taste. Drizzle over the salad. Add Kalamata olives, if using, and garnish with torn mint leaves.

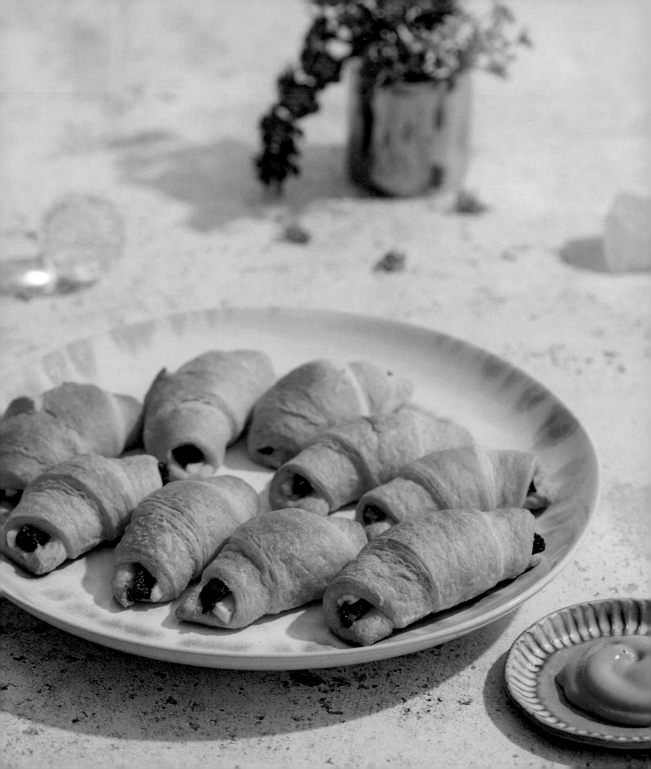

Goddess Goodies

These Goddess Goodies are so simple to make, but they taste like they took a lot of effort. They're a great appetizer to serve at your next party . . . or a family gathering on Mount Olympus.

2 packages crescent roll dough

½ cup goat cheese

Black pepper

16 to 20 large dried figs

Honey mustard, for serving

1. Preheat the oven to 375°F. Line a baking sheet with parchment paper, and set aside.

2. On a wooden cutting board, open both of the crescent roll packages, unroll the dough, and separate the individual pieces.

3. Evenly spread a small amount of goat cheese on each crescent roll, and sprinkle with black pepper.

4. Place 1 or 2 figs, depending on their size, in the center of each roll. Roll up the crescent rolls and place on the baking sheet.

5. Bake for about 12 minutes, or until the rolls are golden. Serve immediately with honey mustard for dipping.

TIP:
IF YOU DON'T LIKE HONEY-MUSTARD, THESE GOODIES GO WELL WITH OUR GREEK GODDESS DRESSING (PAGE 54), KETCHUP, OR DRIZZLED WITH GOLDEN LASSOS OF HONEY.

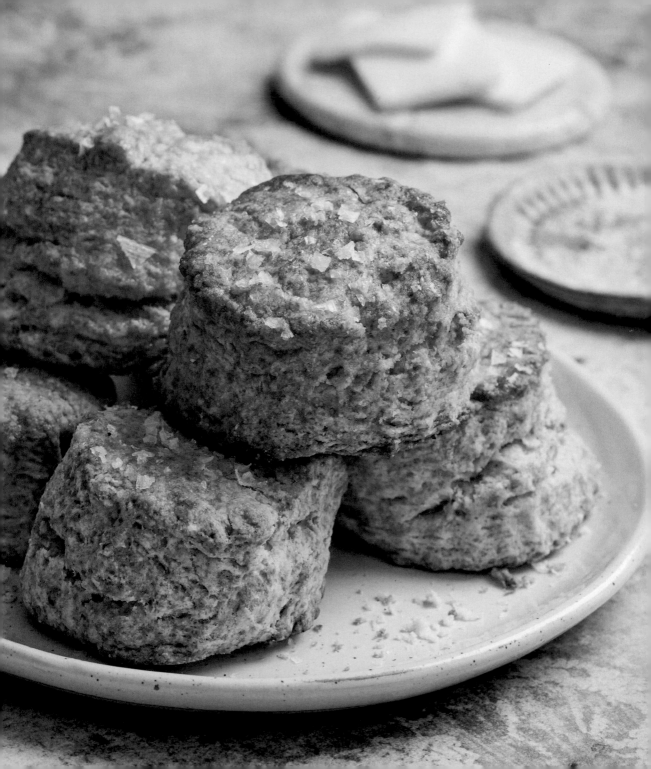

Peaks of Paradise Biscuits

Reminiscent of the cliffs overlooking the ocean on Themyscira, these light and fluffy biscuits will become everyone's favorite thing to see on the dining table. Perfect for breakfast, lunch, or dinner, you can even add some more sugar to the recipe to turn them into a sweet treat for dessert.

3 cups all-purpose flour

1 tablespoon sugar

2 teaspoons baking powder

½ teaspoon baking soda

½ teaspoon salt

1 cup (2 sticks) unsalted butter, cut into 1-inch cubes

½ cup Greek yogurt

1 egg, lightly beaten

2 tablespoons buttermilk, plus more if needed

Pearl sugar, for garnish (optional—for sweet biscuits)

Flaky sea salt, for garnish (optional—for savory biscuits)

1. Preheat the oven to 375°F. Prepare a baking sheet by lining it with parchment paper.

2. In a large bowl, mix together flour, sugar, baking powder, baking soda, and salt. Cut the butter (page 9) into the flour mixture until the mixture reaches the consistency of wet sand.

3. In a small bowl, combine the Greek yogurt, egg, and buttermilk. Using a wooden spoon, mix the yogurt mixture with the flour. The dough should be shaggy but fully incorporated. If there is still a lot of loose flour, add buttermilk 1 tablespoon at a time until the dough comes together. Let the dough sit uncovered for 10 to 15 minutes on the counter.

4. Using a ½ cup measuring cup, scoop the dough and drop about 2 inches apart onto the prepared baking sheet.

5. Bake for 18 to 20 minutes, until the biscuits are golden. Dessert biscuits may take a minute or two longer. Remove from the oven, and sprinkle with pearl sugar (for sweet biscuits) or flaky sea salt (for savory biscuits).

TIP: TURN THESE BISCUITS INTO A SWEET DESSERT BY ADDING 2 MORE TABLESPOONS SUGAR TO THE DOUGH AND USING JUST A PINCH OF SALT INSTEAD OF A ½ TEASPOON.

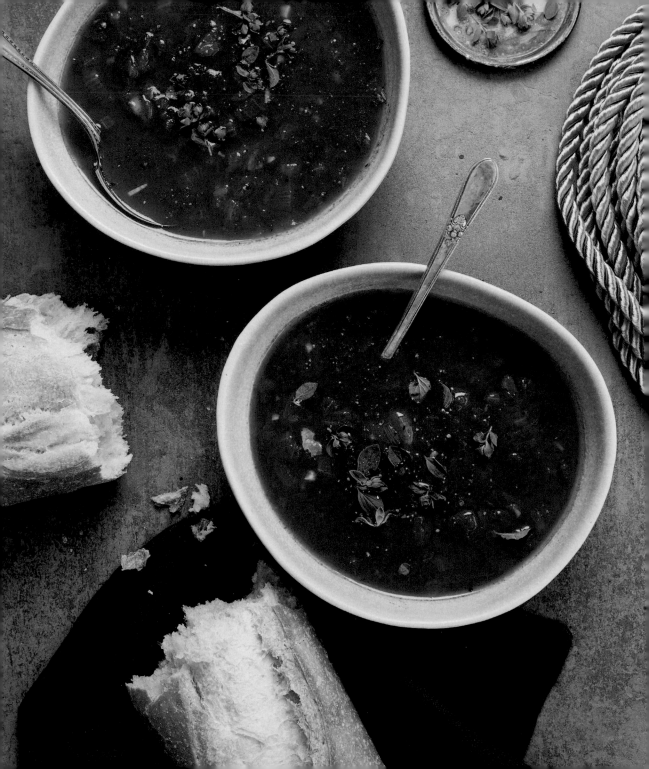

Themyscira Tomato Soup

✶ ✶ ✶ ✶ ✶ YIELD: 4 SERVINGS ✶ ✶ ✶ ✶ ✶

A hearty bean soup that's quick and easy to make, this recipe uses canned tomatoes and beans, leaving very little prep. This dish brings some of the bounty from Themyscira right into your bowl.

2 tablespoons extra-virgin olive oil

1 medium onion, chopped

4 stalks celery, chopped

3 cloves garlic, chopped or crushed

One 14-ounce can whole plum tomatoes

2 tablespoons tomato paste

3 cups vegetable broth

3 cups water

One 14-ounce can kidney beans, drained

1 teaspoon dried oregano

1 tablespoon fresh chopped parsley

Black pepper, to taste

Grated Parmesan cheese, for garnish

Farfalle pasta (optional)

1. In a large skillet, heat the olive oil over medium. When the oil is hot, add the onion and celery, and cook until soft and aromatic, about 6 minutes. Then add the garlic, and cook until aromatic, another 2 minutes.

2. Use a spoon to crush the plum tomatoes in the can and then add to the skillet. Add the tomato paste, and stir until well combined. Add the vegetable broth and water, and let simmer for 10 minutes. Add the kidney beans and dried oregano, cooking for another 15 to 20 minutes, until the beans soften.

3. Stir in the parsley, and season with black pepper to taste. Serve in soup bowls, adding grated Parmesan for garnish.

4. If you want to add a little more heartiness to this soup, you can also cook this with pasta, such as farfalle.

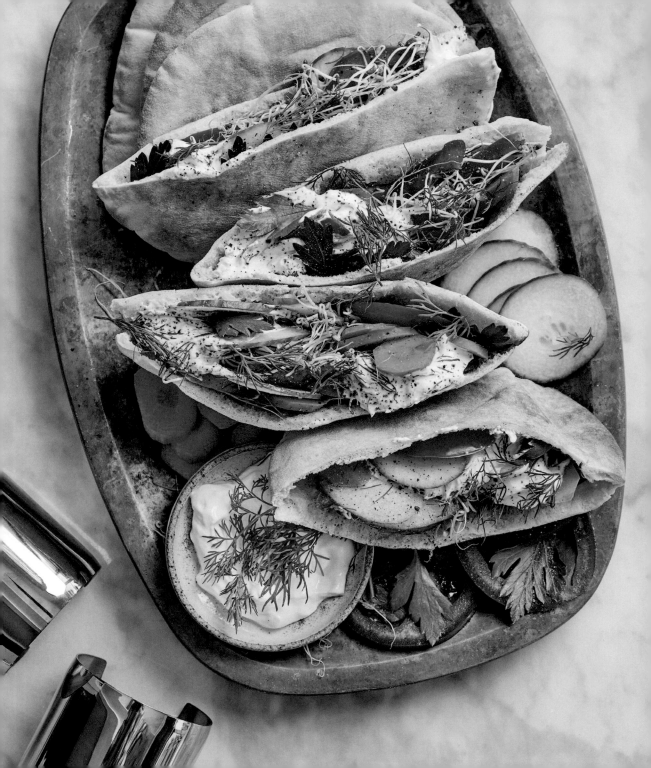

Power-Up Pita Pockets

★ ★ ★ ★ ★ YIELD: 4 SERVINGS ★ ★ ★ ★ ★

Every superhero needs a midday energy boost. Filled with crisp, fresh veggies and garnished with a Greek yogurt dressing, these pita pockets are the perfect snack to help you power through the rest of the day.

2 cups Greek yogurt

½ cup chopped fresh flat-leaf parsley

½ cup chopped fresh dill

3 tablespoons fresh-squeezed lemon juice

½ teaspoon salt

½ teaspoon black pepper

4 rounds pita bread

1 English cucumber, thinly sliced

2 large carrots, thinly sliced into rounds

1 cup alfalfa sprouts

2 medium tomatoes, sliced

1. In a medium bowl, mix together the Greek yogurt, parsley, dill, lemon juice, salt, and pepper. Set aside.

2. Lay the pita on a cutting board, and slice vertically in half. Open the inside of the pita, and evenly layer the cucumbers, carrots, sprouts, and tomatoes into the pocket. Top each Pita Pocket with your desired amount of dressing. Serve with any extra dressing as dip.

Greek Goddess Dressing

★ ★ ★ ★ ★ YIELD: 6 SERVINGS ★ ★ ★ ★ ★

A creamy, dreamy dressing fit for a goddess. It's so versatile you can use it as a dip, marinate protein with it, or use as a condiment for sandwiches. Even the mortals in your life will be begging for more.

½ cup fresh mint

½ cup watercress

½ cup fresh parsley

¼ cup fresh dill

¼ cup fresh basil

3 cloves garlic, chopped or pressed

3 scallions, chopped

1 teaspoon fresh lemon juice

½ cup extra-virgin olive oil

⅔ cup crumbled feta cheese

⅔ cup Greek yogurt

½ cup mayonnaise

Salt

1. Place all the fresh herbs, garlic, scallions, and lemon juice in a food processor and finely chop.

2. While the motor is still running, drizzle in the olive oil, and then add the crumbled feta and blend until incorporated. Add the Greek yogurt and mayonnaise, and continue to blend until everything is well combined.

3. Add salt to taste. This can be kept in the refrigerator, covered, for up to 1 week.

The Dip of Strength and Power

★ ★ ★ ★ ★ YIELD: 6 SERVINGS ★ ★ ★ ★ ★

A strong hit of spinach and a powerful punch of artichoke make this easy, extra-creamy dip a concoction that even spinach haters will be begging to scoop up. Serve hot, or make ahead and serve cold; there is no wrong way to enjoy this. Suit up and use your shields (aka tortilla chips) to dive into battle.

3 tablespoons butter

1 shallot, chopped

1 pound baby spinach leaves

8 ounces cream cheese

1 teaspoon paprika

2 cups canned artichoke hearts, drained and chopped

1 cup heavy cream

2 teaspoons salt

1 teaspoon black pepper

1 cup mozzarella cheese, grated

¼ cup crumbled feta cheese

2 teaspoons lemon juice

Tortilla chips or toasted pita wedges, for serving

1. Preheat the broiler.

2. Melt the butter in a medium saucepan over medium heat. Add the shallot, and cook until aromatic, about 2 minutes. Add the spinach, and cook until all the leaves have wilted and cooked down and any excess liquid has cooked off, about 4 minutes.

3. Add the cream cheese, paprika, artichokes, cream, salt, and pepper, and stir until everything has blended together and is warmed through, about 5 minutes. Fold the mozzarella cheese into the dip, and stir until the cheese is melted.

4. Remove from heat, and scrape the dip into an oven-safe baking dish. Top with the crumbled feta, and place under the broiler for 3 to 5 minutes. Remove when the dip is nice and bubbly.

5. Stir in the lemon juice, and serve with tortilla chips or toasted pita.

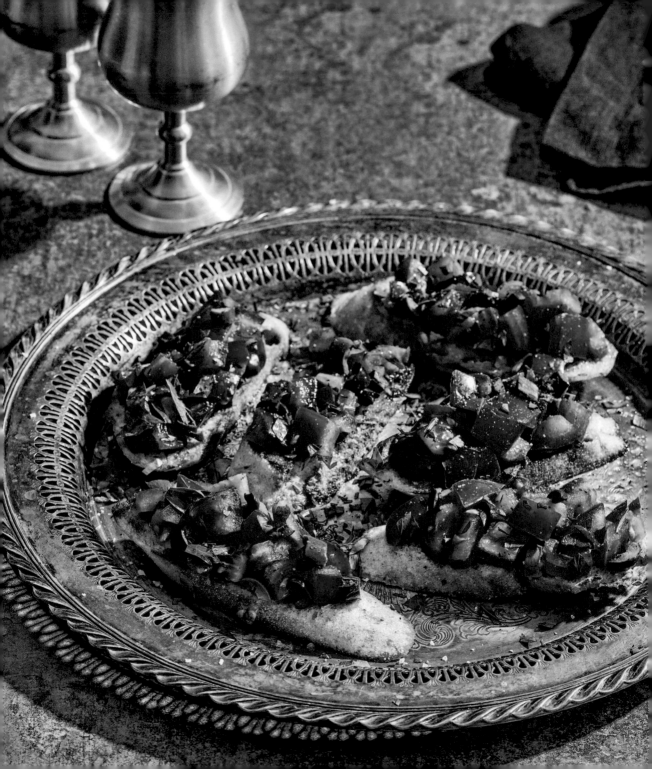

Tomato and Greek Olive Swords

★ ★ ★ ★ ★ YIELD: 6 SERVINGS ★ ★ ★ ★ ★

Defeat your hunger with these tomato and Greek olive "swords." The best time to serve this delectable dish is when tomatoes are in season, and expect a battle at the table for who gets to eat the last one.

6 medium tomatoes, chopped

1½ cups Kalamata olives, pitted and chopped

1 clove garlic, crushed

¼ cup fresh flat-leaf parsley, chopped, plus more for garnish

¼ cup extra-virgin olive oil

1 teaspoon apple cider vinegar

Salt and black pepper

6 slices French bread

1. Preheat the oven to 375°F.

2. In a medium bowl, combine the tomatoes, olives, garlic, chopped parsley, extra-virgin olive oil, and apple cider vinegar. Add salt and pepper to taste.

3. Place the slices of French bread on a baking sheet, and bake for about 8 minutes.

4. Remove the bread from the oven and top with the tomato and olive mix. Garnish with more parsley, and serve immediately.

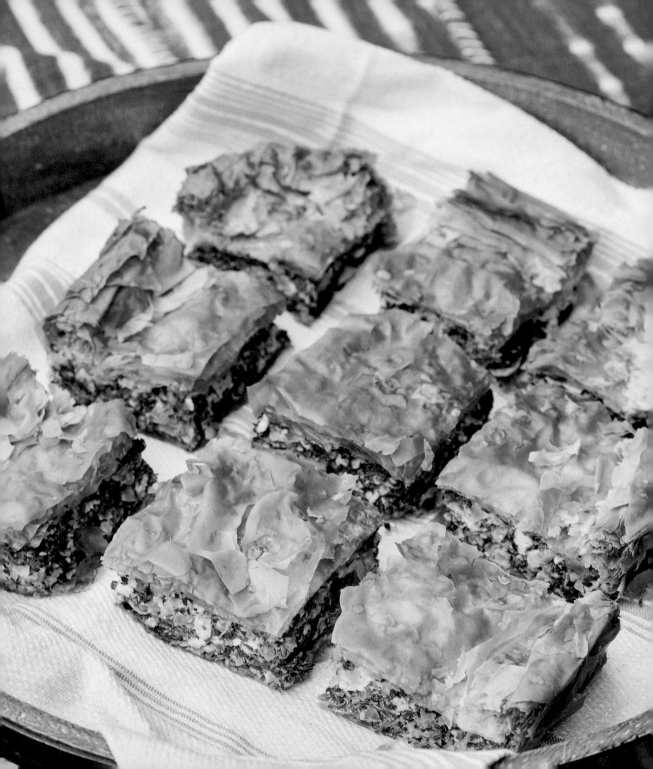

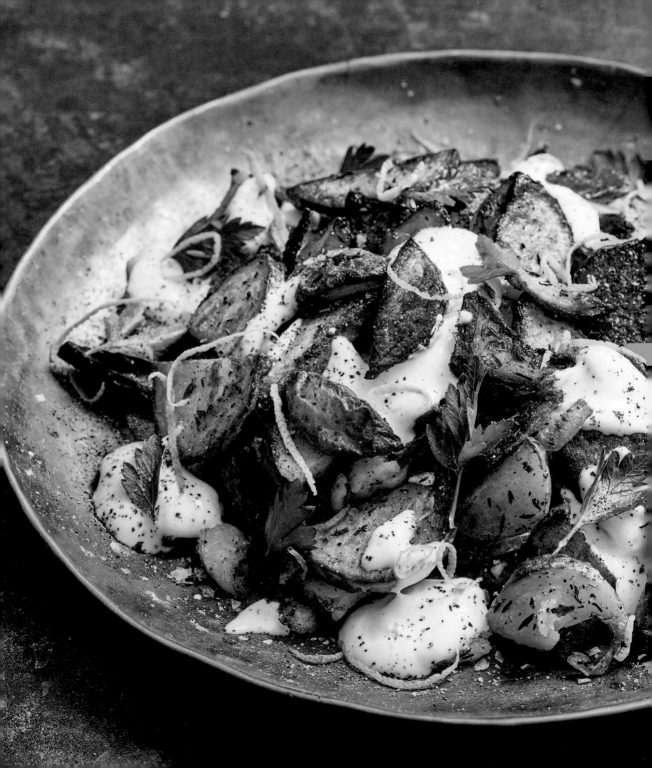

Pallas Athena Popcorn

A more elevated take on the traditional movie snack, this popcorn recipe includes honey and thyme to create a sweet, complex flavor profile. Bringing this to your next movie night might just be the wisest choice you make this week.

6 tablespoons butter, divided

¼ cup white corn kernels

¼ cup honey

1 tablespoon thyme

1 teaspoon salt, for serving

1. In a heavy-bottomed pot, heat half the butter over medium-low. Once the butter has melted, add the corn kernels all at once and cover the pot with its lid. As the kernels start popping, shake the pot to coat all the kernels inside.

2. Increase the heat to medium. Agitate the pot as the kernels keep popping more rapidly. Once you can count to five between pops, your popcorn is done. Remove from heat.

3. In a medium saucepan, heat the remaining butter and honey over medium until they are melted. Add the thyme and stir to incorporate. Add the butter mixture to the popcorn, and shake the pot with the lid on. Pour into a large bowl, sprinkle with salt, and serve immediately.

The Cheetah Chickpea Spread

★ ★ ★ ★ ★ YIELD: 4 SERVINGS ★ ★ ★ ★ ★

Silky and wonderfully rich, this hummus turns lemon and garlic into the stars of the dish. The prep time is shortened with the use of canned chickpeas so you're not soaking all night. Bring this delicious spread and some pita chips on your next expedition, and you'll never lose morale.

Two 16-ounce cans chickpeas, drained and rinsed

3 cloves garlic

1 lemon, juiced

6 tablespoons tahini

1 teaspoon kosher salt

⅓ cup extra-virgin olive oil

Parsley, for garnish (optional)

1. Bring 4 cups of water to a boil in a large pot over high heat. Add the chickpeas, and boil for 15 minutes. Drain the chickpeas, but reserve the water for later.

2. Add the chickpeas, garlic, lemon juice, tahini, salt, and 3 tablespoons of the drained water to a food processor. Pulse 10 times until everything is well blended, and then run the processor until the hummus is smooth. With the processor running, drizzle in the extra-virgin olive oil and continue to blend until combined.

3. Serve immediately, or chill in the refrigerator for up to 3 days. Garnish with more extra-virgin olive oil and parsley if desired.

Sensational Spanakopita

As much of a sensation as Wonder Woman herself, spanakopita is a classic Greek crowd-pleaser that is a welcome addition to any buffet table.

One 1-pound bag frozen chopped spinach, thawed and drained

2 cups fresh flat-leaf parsley, chopped

1 large onion, chopped

3 cloves garlic, crushed

½ cup plus 3 tablespoons extra-virgin olive oil, divided

3 eggs, lightly beaten

1½ cups crumbled feta cheese

2 teaspoons dried oregano

Salt and black pepper

1 package frozen phyllo dough (defrosted at room temperature for 3 hours)

1. Preheat the oven to 350°F.

2. In a medium bowl combine the drained spinach, parsley, onion, garlic, 3 tablespoons of olive oil, eggs, feta, and oregano. Stir until all ingredients are well combined. Season with salt and pepper to taste.

3. Brush a rectangular 9-by-13-inch baking dish with olive oil. Line the baking dish with 2 to 3 sheets of phyllo dough, and brush with olive oil (it's okay if some of the dough hangs over the sides). Add 3 more sheets of dough, and brush with oil again.

4. Spread all the filling evenly on top of the phyllo sheets. Top with 2 to 3 more sheets of phyllo dough, and brush with olive oil. Add one more layer of 2 to 3 sheets of phyllo dough, and brush the last layer with the rest of the olive oil.

5. Bake in the oven until the phyllo dough is golden brown, about 1 hour. Serve immediately or at room temperature.

Gladiator Greek Potatoes

Hearty enough to keep a gladiator going through whatever battles lie ahead, this savory side dish can be transformed into a filling breakfast with the addition of a crispy fried egg on top.

½ cup extra-virgin olive oil

½ cup vegetable broth

¼ cup fresh-squeezed lemon juice

3 pounds Yukon Gold potatoes, cleaned, halved, and cut crosswise

4 cloves garlic, peeled and smashed

2 teaspoons dried oregano

2 teaspoons dried basil

Salt and black pepper

½ cup Greek yogurt

Zest from 1 lemon

1. Preheat the oven to 450°F.

2. In a large bowl, combine the olive oil, broth, and lemon juice. Add the potatoes, and mix together.

3. Transfer the potatoes to an oven-safe skillet or casserole dish. Add the smashed garlic, oregano, and basil, and mix so the potatoes are evenly coated.

4. Roast the potatoes in the oven for 35 minutes, stirring them occasionally to make sure they cook evenly and thoroughly. Cook for another 30 minutes, or until the potatoes are golden and crispy. Remove from the oven. Season with salt and pepper to taste.

5. In a small bowl, combine the Greek yogurt and lemon zest. Add the mixture in dollops to the potatoes right before serving.

MIGHTY
Mains

· · · · · · · · ·

And now presenting cooking's
mightiest heroes: the main dishes.
From a fancy grilled cheese sandwich
to a thick celebratory stew to a tasty
Greek take on nachos, these hearty
and healthy meals will satisfy the
biggest appetites. So gather your
team around the table and get ready
to enjoy a beautiful meal bursting
with a variety of Mediterranean flavors
and influences. Don't worry about
the dishes—they can wait until you're
done saving the world.

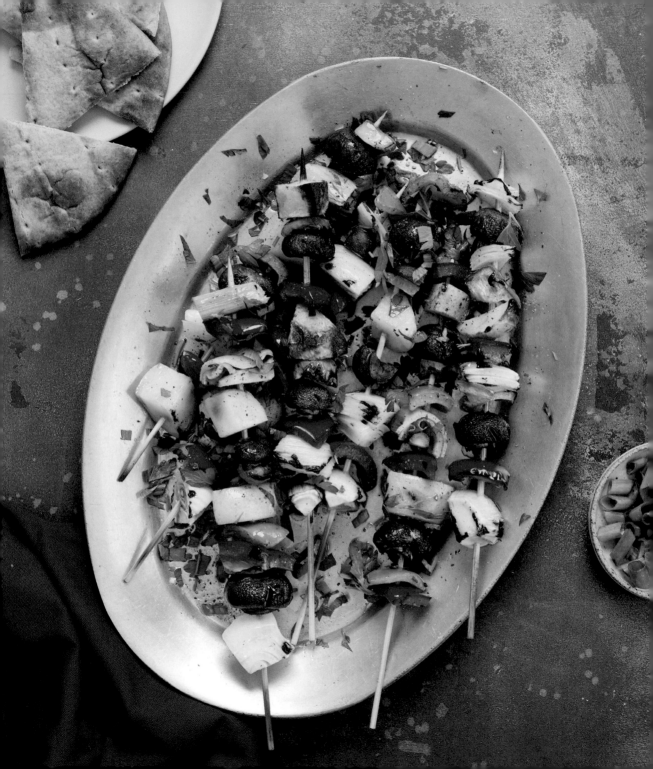

Super-Strength Veggie Kabobs

★ ★ ★ ★ ★ YIELD: 6 SERVINGS ★ ★ ★ ★ ★

Are these pepper, fennel, potato, and mushroom kabobs the secret to super-strength? Eat enough of them and you might find out! This recipe can be grilled or cooked under your oven's broiler, making it perfect all year-round.

½ cup extra-virgin olive oil

¼ cup balsamic vinegar

3 tablespoons honey

2 yellow onions, peeled and cut into wedges

2 red bell peppers, sliced into 2-inch pieces

2 green bell peppers, sliced into 2-inch pieces

4 Yukon Gold potatoes, sliced into 2-inch pieces

15 to 20 cremini mushrooms, stemmed and cleaned

1 large fennel bulb, peeled and cut into wedges

Salt and black pepper

Pita bread, for serving (optional)

SPECIAL SUPPLIES:
Wooden or metal skewers

1. In a small bowl, combine the extra-virgin olive oil, balsamic vinegar, and honey.

2. Spear the vegetables onto the skewers, alternating onions, peppers, potatoes, mushrooms, and fennel, and making sure that the distribution of the vegetables is even on each one. Place the skewers on a large baking sheet.

3. Using a pastry brush or spoon, brush or drizzle the dressing over the vegetable skewers, making sure they're evenly coated on all sides. Season with salt and pepper to taste.

4. If using a grill: Preheat your grill for 5 to 10 minutes before cooking. When the grill is hot, place the skewers directly onto the grill, and cook for about 5 minutes, until the vegetables are nicely browned and soft, rotating halfway through to ensure even cooking.

5. If using a broiler: Preheat the broiler for 5 to 10 minutes before cooking. Adjust your rack so it is in the highest position in the oven. When ready, place the baking sheet with the skewers directly under the flame and cook for about 5 minutes, until vegetables are nicely browned and soft. Rotate the skewers halfway through to ensure all the vegetables are evenly cooked.

6. Serve the veggies on the skewer, or remove from the skewers and serve on pita bread.

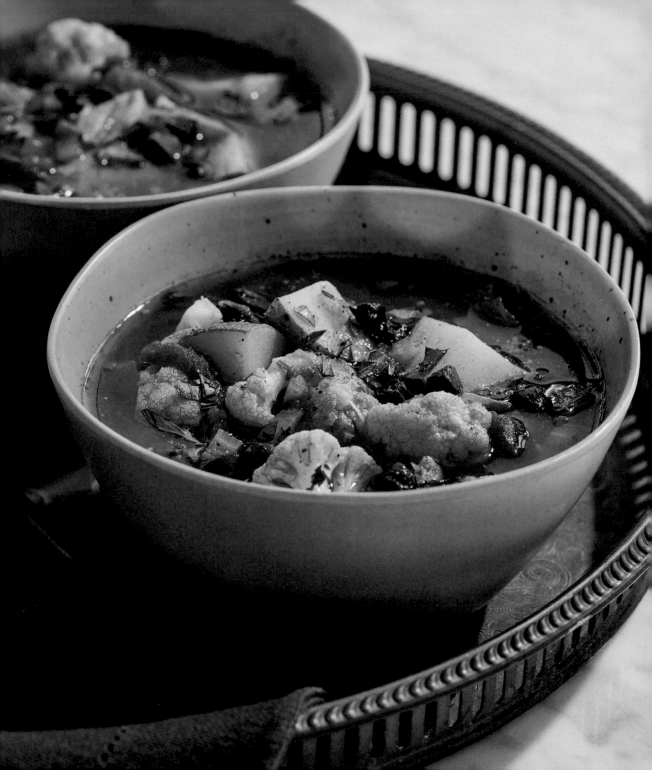

The Feast of Five Greek Stew

★ ★ ★ ★ ★ YIELD: 4 SERVINGS ★ ★ ★ ★ ★

Inspired by the celebrations of Themyscira's festival honoring the goddesses Artemis, Athena, Demeter, Hestia, and Aphrodite, this easy-to-assemble stew filled with strong Greek flavors will feed everyone gathered around your table.

3 tablespoons extra-virgin olive oil, plus more for garnishing

4 cloves garlic, crushed

1 red onion, chopped

Two 14-ounce cans crushed tomatoes

1 teaspoon cayenne pepper

½ teaspoon ground cumin

½ teaspoon dried thyme

1 head cauliflower, broken into florets

10 small red potatoes, halved

2 cups Kalamata olives, pitted and chopped

2 teaspoons apple cider vinegar

Salt and fresh ground black pepper

Fresh flat-leaf parsley, for garnish

1. In a large high-sided skillet, heat the olive oil over medium-high. Add the garlic and cook, stirring, for about 30 seconds. Turn the heat to medium-low, and add the onion, stirring often until the onion softens, about 5 minutes.

2. Add the crushed tomatoes with their juice, cayenne, cumin, thyme, and 2 cups of water to the skillet. Turn up the heat to medium, and bring to a simmer, stirring often.

3. Add the cauliflower, potatoes, and olives to the pot. Return to a simmer, and let the stew cook for about 20 minutes, until the cauliflower and potatoes are soft. Add the apple cider vinegar, and season with salt and pepper to taste.

4. Serve hot in bowls topped with parsley, olive oil, and fresh ground black pepper.

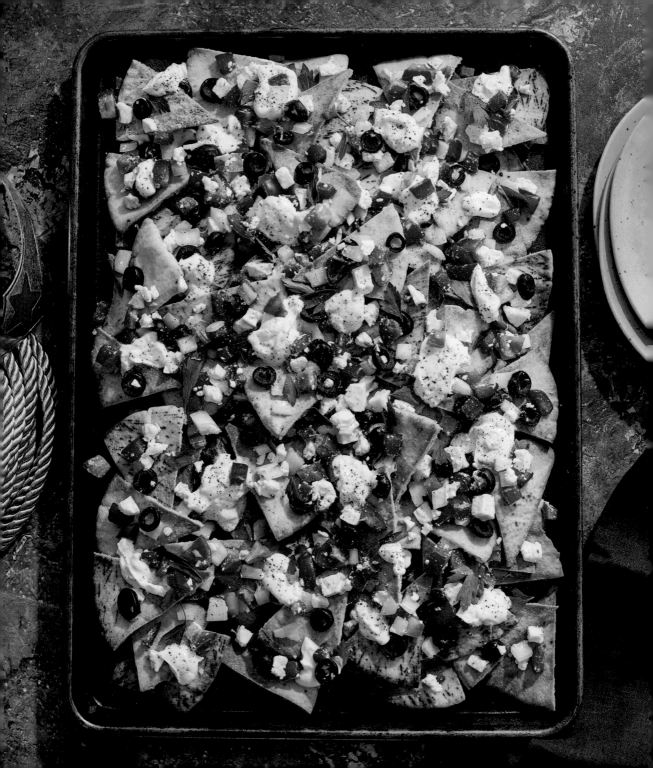

Feed the League Nachos

A long day saving the world makes for some hungry superheroes. These delicious Mediterranean nachos are a lighter, healthier take on the traditional dish but still filling enough to feed every member of your league.

4 to 6 pieces of pita bread, cut into chip-sized wedges

½ cup extra-virgin olive oil

½ cup feta cheese

¼ cup sliced black olives

1 medium yellow onion, chopped

2 tomatoes, chopped

2 red bell peppers, seeded and chopped

Salt and black pepper

½ cup Greek yogurt

Zest from 1 lemon

1 teaspoon cumin

1. Preheat oven to 350°F.

2. Line a baking sheet with aluminum foil. Arrange the pita wedges on the sheet and drizzle with about half the extra-virgin olive oil. Bake for 5 to 10 minutes, until they start crisping.

3. While the pita is baking, combine the feta, black olives, onion, tomatoes, and bell pepper in a large bowl. Drizzle with the remaining extra-virgin olive oil, and add salt and pepper to taste. When the pita is done, remove the sheet from the oven and top the crispy pita wedges with the veggie mixture.

4. Return the sheet to the oven, and bake for 15 to 20 minutes, until the cheese has started to melt. Remove from oven.

5. In a small bowl, combine the Greek yogurt, lemon zest, and cumin. Drop dollops of the yogurt mixture on top of the nachos, and serve immediately.

Powered by Peppers Pasta

Find your "inner Diana" and take charge of dinner with this powerful roasted pepper pasta recipe. The roasted red bell peppers are the hero, rendered even more flavorful by fire and smoke (i.e., being cooked at high heat on the stove). Bring this dish to your next potluck, and wow the world with your cooking prowess.

1 pound penne pasta

2 tablespoons extra-virgin olive oil

2 to 3 cloves garlic, crushed

1½ cups sliced jarred roasted sweet red peppers

Salt and black pepper

½ cup crumbled feta cheese

⅛ cup thinly sliced fresh basil leaves

1. Cook the pasta per the package directions. Drain the pasta, reserving ⅓ cup of the pasta water.

2. In a large skillet, heat the olive oil over medium. Add the garlic, and stir until aromatic, about 1 minute. Add the red peppers, and season with salt and pepper to taste. Cook the mixture for 2 to 3 minutes, until everything has warmed up.

3. Add the feta and pasta water to the mixture. Stir well so the feta becomes creamy and melts, about 5 minutes.

4. Add the pasta to the pan, stirring well so the pasta is evenly coated with the sauce. Transfer everything into a serving bowl, and garnish with the basil.

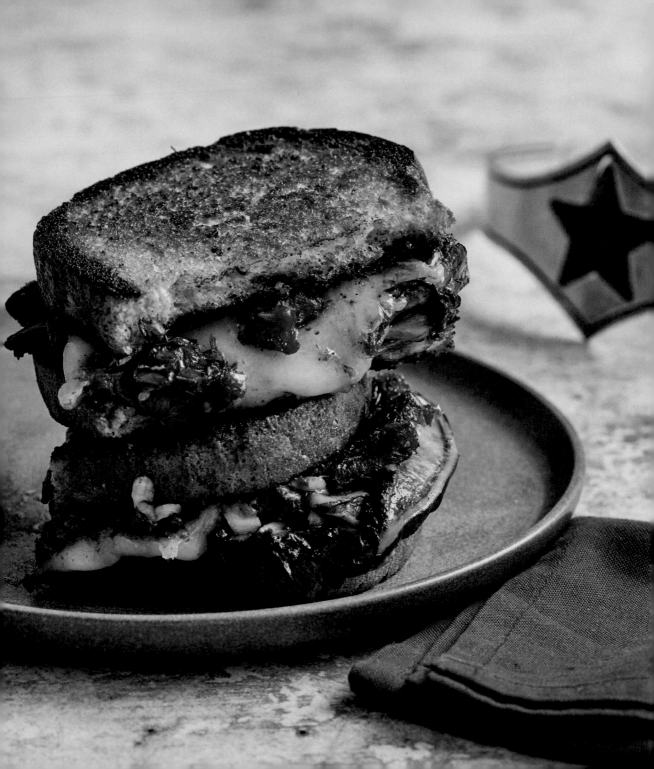

Mercury Mushroom Melt

✴ ✴ ✴ ✴ ✴ YIELD: 4 SERVINGS ✴ ✴ ✴ ✴ ✴

Inspired by the speed of the messenger god Mercury, this delicious sandwich is incredibly quick to make but filled with amazing flavors from the portobello mushrooms, sun-dried tomatoes, and three different kinds of cheese. It's the perfect sandwich for a slightly elevated, at-home lunch.

8 slices rye bread

1 clove garlic, peeled

1 tablespoon extra-virgin olive oil

2 large portobello mushrooms, sliced

1 cup sun-dried tomatoes

1 cup grated manchego cheese

½ cup grated Parmesan cheese

½ cup grated mild cheddar cheese

1. Rub both sides of each slice of bread with the garlic clove. Heat the olive oil in a large skillet or sauté pan over medium-high. Once the oil is hot, add two slices of bread to the skillet. On one slice, add a layer of portobello mushrooms topped with manchego cheese. On the other, add a layer of sun-dried tomatoes, topped with the Parmesan and cheddar cheeses. Turn down the heat to medium, cover, and cook for about 5 minutes, until the cheese has started to melt.

2. Once the cheese has begun to melt, use a spatula to carefully lift the slice with the sun-dried tomatoes and fold it over the slice with the mushrooms. Finish cooking the sandwiches for another 5 to 8 minutes, until the cheese has all melted together, flipping occasionally so each side gets evenly cooked. Repeat with remaining slices of bread until you have four sandwiches.

3. Cut each sandwich in half, and serve hot alone or with Themyscira Tomato Soup (page 51).

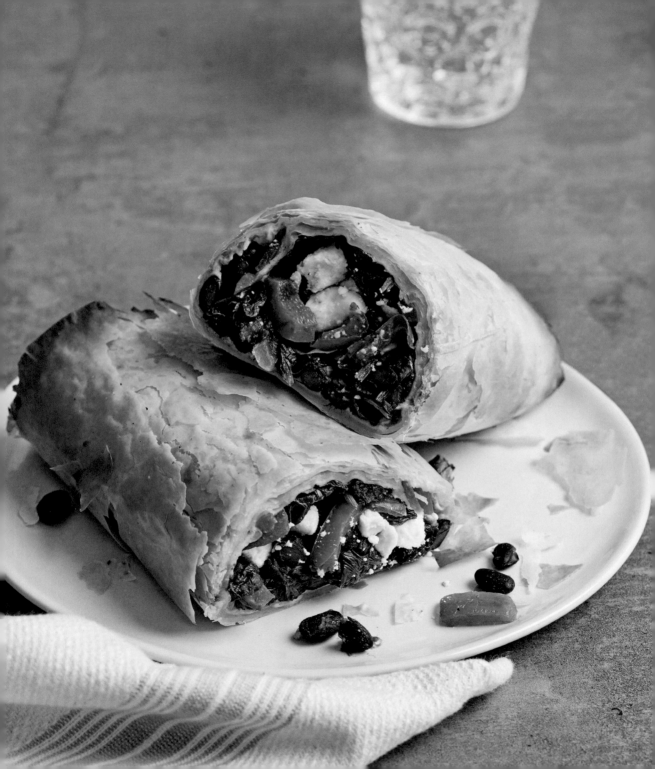

Fearless Phyllo Dough Burrito

An Amazon warrior is fearless in the face of danger, deception . . . and phyllo dough. Phyllo dough might seem intimidating, but it's actually very easy to work with. The key is layers. Use plenty of layers to build this burrito strong and keep all the ingredients inside. Filled with flavors inspired by Paradise Island, it is impossible to turn down this Amazonian twist on a burrito.

FOR THE BURRITO:

1 cup black beans, drained

One 1-pound bag frozen spinach, thawed and drained

1 medium red onion, chopped

2 orange bell peppers, sliced

1 package phyllo dough, defrosted per the box's instructions (generally 3 hours)

1 tablespoon extra-virgin olive oil

½ cup fresh cilantro, picked off the stems

1 cup crumbled feta cheese

½ cup sliced black olives

FOR THE DIP:

1 cup Greek yogurt

¼ cup chopped fresh dill

1 clove garlic, crushed

½ cup cucumber, peeled and chopped

1. Preheat the oven to 350°F.

2. In a large saucepan, combine the beans, spinach, onion, and peppers over medium heat. Cook until all the liquid from the spinach is gone, about 15 minutes. Remove from heat.

3. Roll out the phyllo dough, and create four stacks of about 10 sheets each. Using a pastry brush, lightly brush each layer of phyllo with the olive oil.

4. Evenly distribute the bean mixture among the four phyllo dough stacks, letting the mixture spread out no more than halfway down the dough. Sprinkle the cilantro, feta cheese, and black olives on top of the mixture.

5. Working with one burrito at a time, fold the sides in, then tightly roll the burrito from the bottom up. Place seam side-down on a foil-lined baking sheet.

6. Bake for 20 to 25 minutes, until the phyllo is golden and crispy.

7. To make the dip, stir together the Greek yogurt, dill, garlic, and cucumber in a small bowl.

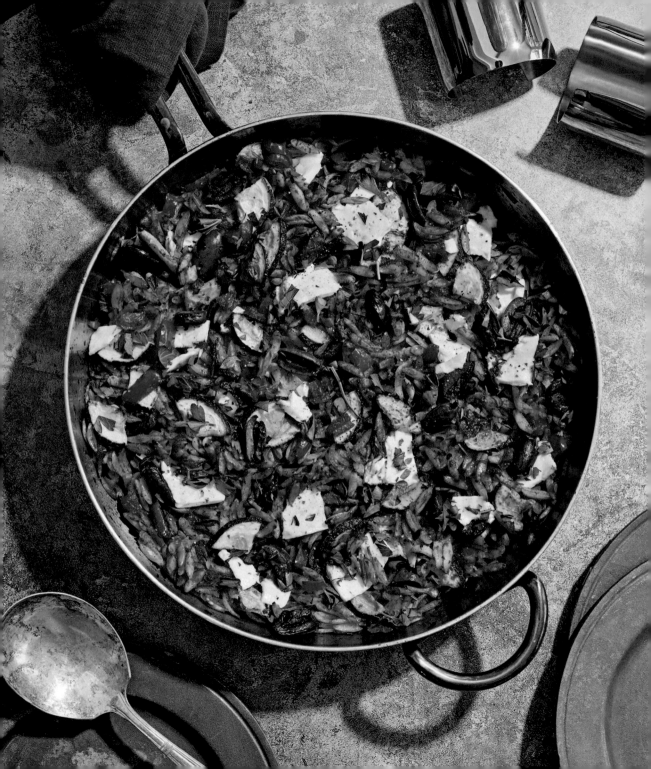

Olympian Orzo

★ ★ ★ ★ ★ YIELD: 8 SERVINGS ★ ★ ★ ★ ★

You can't mess up this easy-to-bake pasta entrée! Loaded with zucchini, red bell peppers, tomatoes, and celery, the one-pot meal requires little to no prep and makes enough to feed every god on Olympus.

2 tablespoons extra-virgin olive oil

1 small onion, chopped

1 cup chopped celery

2 zucchini, cut into rounds

3 cloves garlic, crushed

2 red bell peppers, chopped

2 teaspoons dried oregano

1 teaspoon black pepper

1 teaspoon salt

One 28-ounce can whole plum tomatoes

3 tablespoons tomato paste

1 cup orzo

2 cups vegetable stock

1 cup crumbled feta cheese

½ cup Kalamata olives, pitted and crushed

⅓ cup chopped fresh flat-leaf parsley

Juice from ½ lemon

1. Preheat the oven to 375°F.

2. In a large oven-safe skillet, heat the oil over medium. Add the onion, celery, and zucchini, and cook until soft, about 5 minutes. Add the garlic, and stir for about 30 seconds. Add the red bell pepper, oregano, black pepper, and salt. Cook, stirring consistently, for another 5 minutes.

3. Use a spoon to crush the canned tomatoes in the can, add to the skillet along with the tomato paste, and bring to a high simmer. Add the orzo, and cook on the stove top for about 5 minutes, until the orzo is slightly tender but not fully cooked.

4. Add the vegetable stock, and bring back to a boil. Turn off the heat, and place the whole skillet in the oven. Cook for about 15 minutes, until the orzo is soft.

5. Remove from the oven, and top with feta and olives. Place back into the oven, and cook for another 5 minutes, until the cheese has melted.

6. Remove from the oven, and garnish with parsley and lemon juice before serving.

TIP:
FEEL FREE TO SPICE UP THIS DISH WITH RED PEPPER FLAKES OR HOT SAUCE; IT CAN BE A FUN WAY FOR YOUR BRAVE WARRIORS TO TRY NEW FLAVORS.

Steve Trevor Egg Salad

★ ★ ★ ★ ★ YIELD: 2 SERVINGS ★ ★ ★ ★ ★

Steve Trevor is an old-fashioned American hero who always likes to do things his own way, and this egg salad is no different. Inside you'll get all the crunch and flavor of a traditional deli egg salad, with the added touches of olives and parsley. Serve on a bed of lettuce, or in a sandwich for a heartier meal.

8 large eggs

½ cup mayonnaise

1½ teaspoons Dijon mustard

1 teaspoon Worcestershire sauce

2 stalks celery, chopped

¼ cup chopped green olives

2 tablespoons chives, chopped

Salt and black pepper

4 slices bread of your choice

4 leaves Romaine lettuce

1. Bring a medium pot of water to a boil over high heat. Gently place the eggs in the water, and cook for 8 minutes, or until hard. While they are cooking, prepare an ice bath by filling a large bowl with ice and water. When the eggs are done, use a slotted spoon to remove them from the water, and place them directly into the ice bath to stop them from continuing to cook.

2. Peel and rough chop the eggs. In a medium bowl, combine the eggs, mayonnaise, Dijon mustard, Worcestershire sauce, celery, olives, and chives. Mix until well combined. Add salt and pepper to taste.

3. Lightly toast the four slices of bread. Spread two of the slices with the egg salad, layer with Romaine, and top with the other two slices of bread.

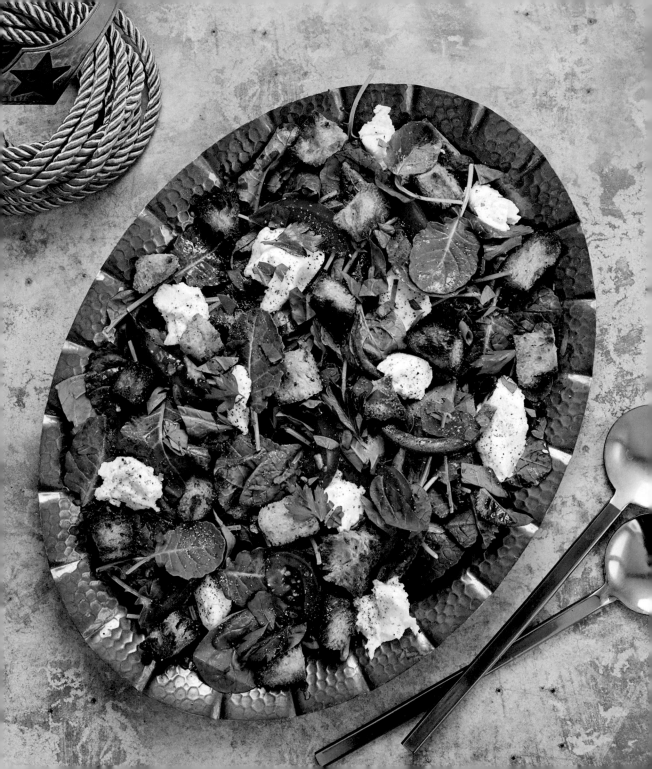

Amazonian Panzanella

Grilling one side of thick pieces of bread gives this "salad" a satisfying crunch. With ricotta, basil, tomatoes, garlic, and a red wine vinaigrette, this panzanella is truly Amazon-worthy.

4 large slices country-style bread

1 clove garlic, peeled

½ cup plus 5 tablespoons extra-virgin olive oil

¼ cup red wine vinegar

2 tablespoons fresh lemon juice

½ cup chopped fresh flat-leaf parsley

Salt and black pepper

2 shallots, finely chopped

1 pound arugula or baby kale

2 tomatoes, sliced into thin wedges

1 cup ricotta cheese

½ cup fresh basil leaves

1. Preheat the oven to 400°F.

2. Rub the bread slices with the garlic clove. Tear the bread into small chunks, and spread it in a single layer on a large baking sheet. Drizzle with 2 tablespoons of extra-virgin olive oil. Bake for about 10 minutes, until the bread is slightly crunchy.

3. In a small bowl, combine the red wine vinegar, lemon juice, ½ cup extra-virgin olive oil, and parsley. Add salt and pepper to taste, and whisk until well combined. Set aside.

4. In a large bowl, combine the shallots and greens. Season with salt and pepper, and drizzle with 3 tablespoons extra-virgin olive oil. Mix well.

5. On a serving platter, layer the greens mixture with the tomatoes, dollop the ricotta all over the top, and scatter the torn bread over the dish. Garnish with basil. Drizzle salad with dressing and serve.

Baked Vegetables of the Warrior

★ ★ ★ ★ ★ YIELD: 4 SERVINGS ★ ★ ★ ★ ★

The Amazon warriors keep their bodies in perfect fighting shape through an intense training regimen and plenty of healthy eating. Packed with potatoes, zucchini, eggplant, and onions and then smothered in a tomato sauce, this dish is the perfect entrée for the warrior inside you.

1 pound small or fingerling potatoes, halved

1 large eggplant, sliced

4 zucchini, thickly sliced

2 large onions, peeled and cut into wedges

1 fennel bulb, peeled and sliced

Two 28-ounce cans chopped tomatoes

½ teaspoon dried oregano

½ teaspoon Aleppo pepper

1 teaspoon salt

1 teaspoon black pepper

⅛ cup extra-virgin olive oil

Fresh flat-leaf parsley, for garnish

Garlic bread, for serving (optional)

1. Preheat the oven to 400°F.

2. In a large baking dish, combine the potatoes, eggplant, zucchini, onion, and fennel.

3. Pour the two cans of tomatoes, with their juice, on top of the veggies. Season with oregano, Aleppo pepper, salt, and black pepper.

4. Bake for 30 minutes, or until the potatoes are easily pierced with a fork. Remove the veggies from the oven and drizzle with olive oil. Garnish with fresh parsley. Serve with garlic bread.

Nubia Grilled Cheese and Fig Sandwich

★ ★ ★ ★ ★ YIELD: 2 SANDWICHES ★ ★ ★ ★ ★

An alternate version of a beloved classic that's just as good as the original, this sandwich, named for Nubia, Wonder Woman's sister, makes for a delicious light lunch all year-round.

4 thick slices country loaf bread

¼ cup cream cheese

12 dried figs

½ cup soft goat cheese

2 teaspoons honey

Salt and black pepper

2 to 3 tablespoons butter

1. Preheat a cast-iron skillet over medium-low heat.

2. Spread the cream cheese on two slices of bread. Add the figs, dividing them evenly between the two slices. On the other two slices of bread, evenly spread the goat cheese. Drizzle the goat cheese slices with honey, and season with salt and pepper to taste.

3. Melt the butter in the skillet. Place all four bread slices faceup in the skillet. Cover the pan, and cook for about 6 minutes, or until the cheeses start to melt.

4. Once the cheeses start to melt, put the sandwiches together, topping the goat cheese slices with the cream cheese slices. Flip the sandwiches so both sides cook evenly, until they are golden brown and the cheese is gooey, about 10 minutes.

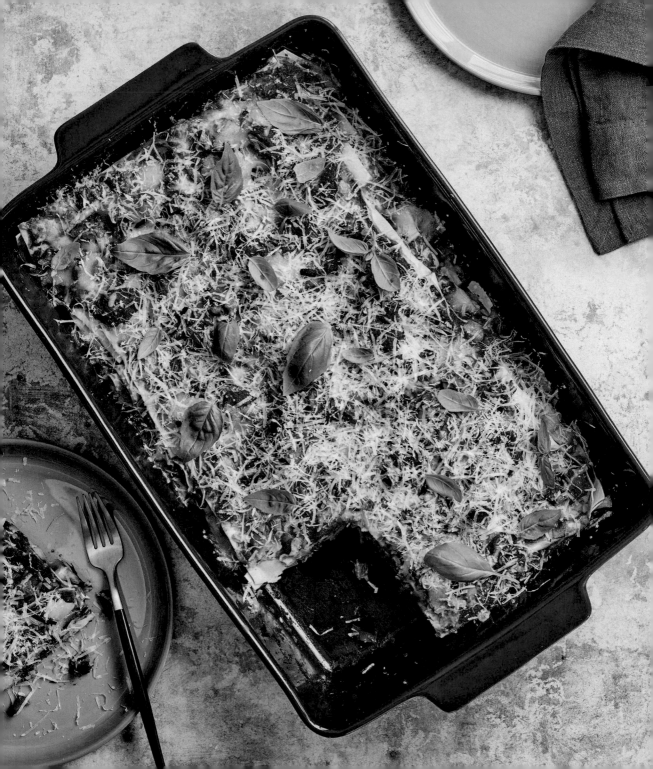

Justice League Lasagna

★ ★ ★ ★ ★ YIELD: 6 SERVINGS ★ ★ ★ ★ ★

The Justice League is made up of the biggest Super Heroes in the DC Universe: Wonder Woman, Superman, Batman, Aquaman, and many more. And big superheroes have big appetites. Bring the whole team together with this vegetarian lasagna that's filled with ricotta, tomatoes, and eggplant. It's big enough to feed all the good guys, so they'll be ready to go when duty calls!

2 tablespoons extra-virgin olive oil

3 large carrots, chopped

1 medium yellow onion, chopped

2 red bell peppers, sliced

Salt and black pepper

1 medium eggplant, sliced

2 cups baby spinach

One 28-ounce can crushed tomatoes

¼ cup fresh basil, chopped

2 cloves garlic, crushed

1 teaspoon red pepper flakes

2 cups ricotta cheese

½ teaspoon dried oregano

½ teaspoon dried thyme

12 no-boil lasagna noodles

½ cup grated Parmesan cheese

1. Preheat the oven to 375°F.

2. In a large skillet over medium-high, heat the olive oil until shimmering. Add the carrots, onion, and bell peppers, and cook until they start to soften, about 5 minutes. Lightly season with a pinch of salt and some fresh ground black pepper. Add the eggplant and cook, stirring occasionally, for another 3 to 5 minutes, or until the eggplant is golden on both sides. Add the baby spinach, and cook just until it has all wilted and any excess liquid in the pan has evaporated, about 8 minutes. Add a teaspoon of oil if the vegetables start to stick to the pan.

3. In a medium saucepan, add the crushed tomatoes, and bring to a simmer over medium-high heat. Turn down the heat to medium, and add the fresh basil, garlic, and red pepper flakes. Season with salt and pepper to taste, and cook for another 5 minutes. Do not allow the tomatoes to get above a simmer.

4. In a medium bowl, combine the ricotta, oregano, and thyme, mixing together well.

Continued on page 90

5. To assemble the lasagna: Spread a small spoonful of the tomato sauce over the bottom of a 9-by-13-inch baking dish. Add your first layer of 3 lasagna noodles, then add a layer of vegetables and ricotta, and top with the tomato sauce. Repeat 2 more times, finishing with a layer of lasagna noodles topped with tomato sauce.

6. Cover the lasagna with aluminum foil, and bake for 45 to 50 minutes, until the dish is bubbly and the noodles are fully cooked. Remove the aluminum foil, and sprinkle the lasagna with Parmesan cheese. Bake for another 5 minutes. Remove from the oven, and let the lasagna sit for 10 minutes to slightly cool. Serve while still hot.

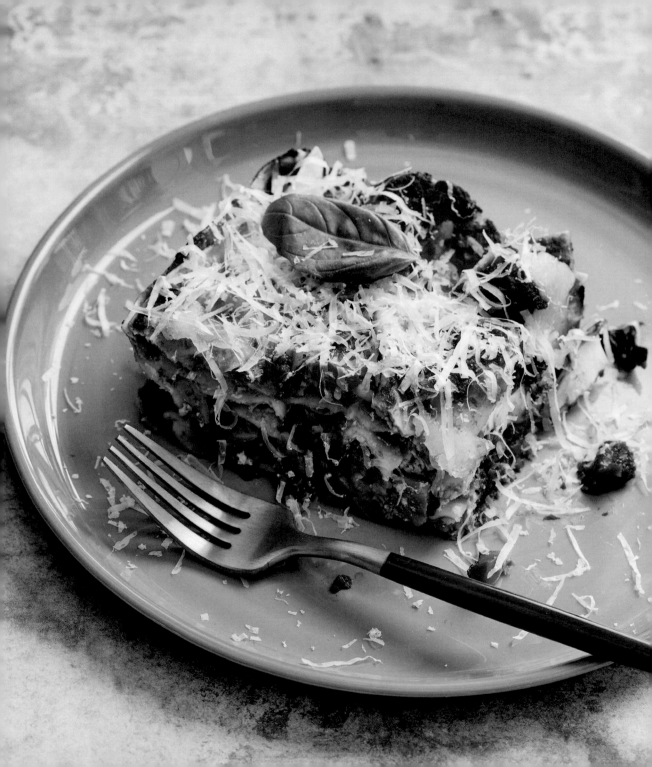

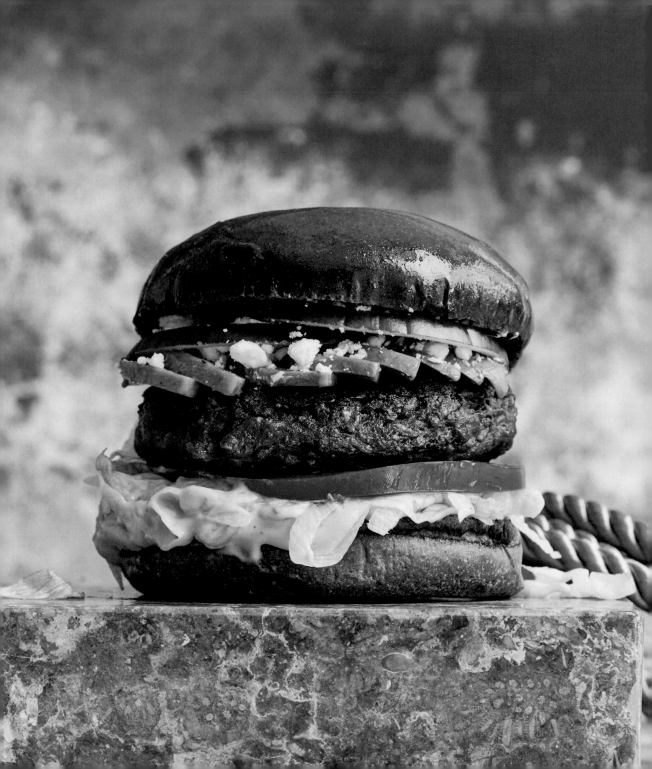

Zeus Burgers

★ ★ ★ ★ ★ YIELD: 4 SERVINGS ★ ★ ★ ★ ★

Named in honor of Zeus, the king of the gods who is known to disguise himself in many forms, these burgers are so tasty you'll never guess the "meat" in them is actually a plant-based substitute in disguise. Get out some of your godly aggression by "smashing" them in the pan, and you'll have a burger that's not just healthy, but super flavorful.

FOR THE SAUCE:

1 cup mayonnaise

3 tablespoons ketchup

3 tablespoons sweet relish

2 teaspoons sugar

2 teaspoons cayenne pepper

Salt and black pepper

FOR THE BURGER:

1½ pounds plant-based "meat"

1 tablespoon extra-virgin olive oil

½ medium red onion, sliced into rounds

½ cup crumbled feta cheese

4 soft buns

1 tomato, sliced

1 avocado, peeled and sliced

1½ cups shredded iceberg lettuce

1. In a small bowl, combine the mayonnaise, ketchup, relish, sugar, and cayenne pepper, adding salt and pepper to taste. Stir well, and set aside.

2. Form the plant-based meat into 4 evenly sized patties, approximately ½ inch thick (you'll be smashing them during cooking).

3. In a large cast-iron skillet, warm olive oil on medium-high. When the oil is shimmering, add the burger patties one at a time, smashing each one for about 15 seconds with the back of a spatula to flatten it. Cook for about 4 minutes.

4. Flip the burgers, and smash again for about 10 seconds per burger. Place a few slices of onion on top of each patty, and top with cheese. Cover the pan for 4 to 5 minutes. Uncover, and let the patties rest on a plate.

5. Open the buns, and place them on a baking sheet. Place them under the preheated broiler for 30 seconds until lightly toasted (do not let them get too brown).

6. Coat the bottom half of each bun with the sauce (you can do the top as well, if you like!), and add tomato, avocado, and lettuce. Add the patties, and finish with the top half of each bun.

SUPERHERO
Sweets

· · · · · · · ·

Every hero has a sweet side, and now it's time to bring out yours with these sensational desserts! Consider them your reward for saving the world on a near-daily basis. Some heroes get the key to the city; others get their choice of colorful iced cookies, luscious cakes, and other decadent delights. Great for special occasions or everyday after-dinner treats, these scrumptious sweets are the perfect finale to any superpowered meal.

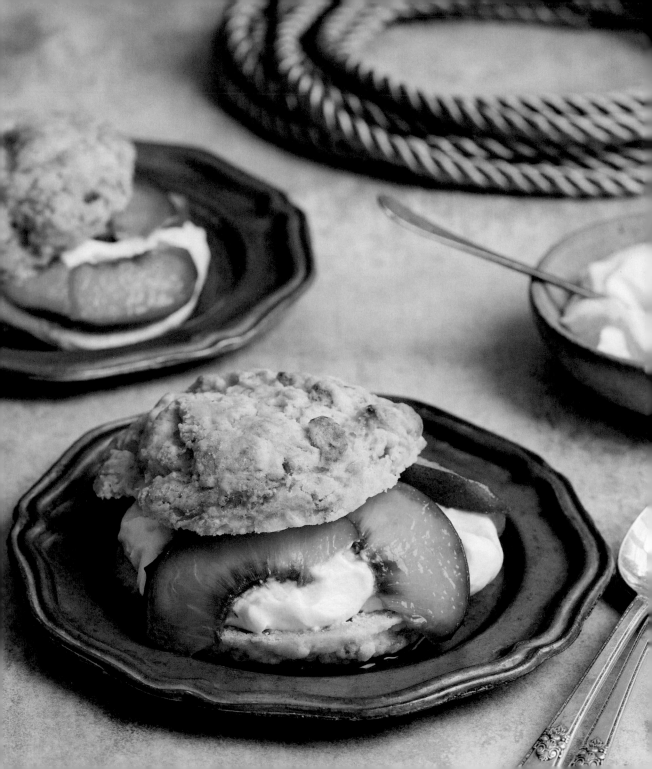

Golden Lasso Peach Shortcake

This recipe turns peaches into a golden syrup that's drizzled, rope-like, over a light, delicious shortcake. Serve for dessert or for breakfast with fluffy whipped cream or ice cream!

4 ripe golden peaches

½ cup light brown sugar, tightly packed

4 cups cake flour (all-purpose flour will work too)

3 tablespoons white sugar

½ teaspoon salt

5 teaspoons baking powder

½ cup unsalted butter, cubed

1½ cups buttermilk

¼ cup heavy cream

Whipped cream or ice cream, for serving (optional)

3 fresh sprigs of rosemary for garnish (optional)

1. Preheat the oven to 450°F. Prepare a baking sheet by lining it with parchment paper. Set aside.

2. Slice and pit the peaches. Heat a large nonstick skillet over low heat. Add half the peaches and the brown sugar to the skillet and cook, stirring regularly, until the sugar slightly caramelizes and creates a syrup, about 5 minutes. Remove from heat and stir in the rest of the peaches.

3. In a large bowl, combine the flour, white sugar, salt, and baking powder. Cut the butter into the flour mixture with your hands until a dry, crumb-like mixture forms.

4. Add the buttermilk to the flour mixture, and stir with a wooden spoon until a soft dough forms. Turn the dough out onto a lightly floured surface, and gently knead the dough until the liquid is evenly incorporated, about 5 minutes. Do not overknead; a shaggy dough is perfectly acceptable. Roll out the dough to ½-inch thickness. Use a biscuit cutter or the top of a water glass to cut out 8 biscuits.

5. Place biscuits evenly on the prepared baking sheet, and brush the tops of the biscuits with cream or whole milk. Bake for 10 minutes or until golden brown.

6. To serve, slice the biscuits in half. Place the bottom half of each biscuit on a plate, spoon an even amount of the peaches and sauce on top, and top with the second half. Serve with whipped cream or ice cream and garnish with rosemary.

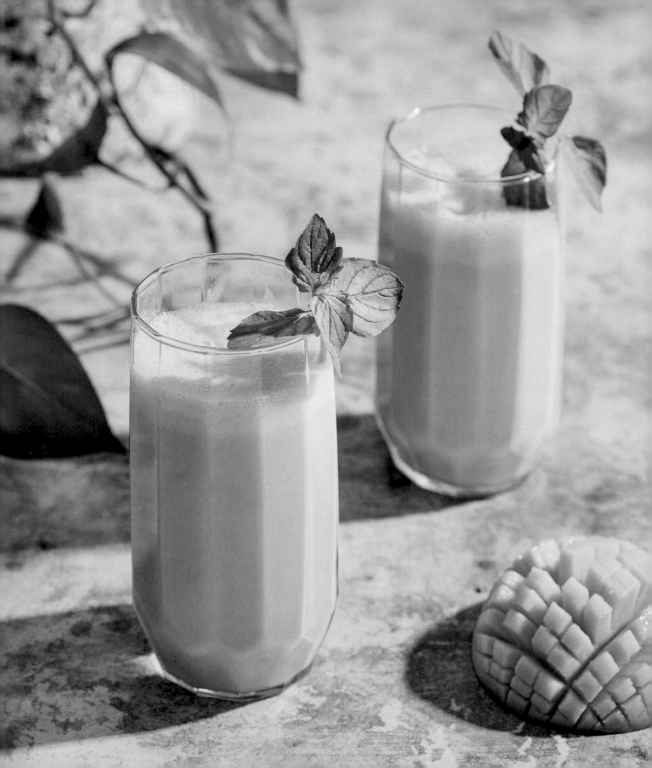

Mango Lassi of Truth

★ ★ ★ ★ ★ YIELD: 2 SERVINGS ★ ★ ★ ★ ★

It's no lie—this sweet mango drink is delicious and refreshing. A perfect end to a hero's busy day, the tasty treat adds Greek yogurt to a traditional lassi.

2 cups frozen mango chunks

1 cup Greek yogurt

½ cup whole milk

2 tablespoons sugar

1 pinch salt

1 pinch cinnamon, for garnish

1. Add all ingredients except cinnamon to a blender. Blend on medium-high until smooth.

2. Pour into two glasses and serve immediately. Garnish with a pinch of cinnamon.

Etta Candy's Candy Cookies

★ ★ ★ ★ ★ YIELD: 24 COOKIES ★ ★ ★ ★ ★

One of Diana's closest friends and allies, fierce Etta Candy is unapologetically proud of her opinions and her love of sweets. Named in her honor, these candy-packed cookies feature chocolate chips, peanut butter chips, and candy pieces, which should be enough to satisfy any sweet tooth.

1½ sticks unsalted butter, room temperature

1 cup white sugar

2 cups light brown sugar, tightly packed

2 cups creamy peanut butter

4 large eggs, room temperature

1½ teaspoons vanilla extract

2 teaspoons baking soda

1 cup all-purpose flour

4½ cups rolled oats (not instant)

½ cup chocolate chips

½ cup peanut butter chips

1 cup candy-coated chocolate pieces

1. In the bowl of a stand mixer fitted with the paddle attachment on high speed, cream the butter, white sugar, and brown sugar until light and fluffy. Add the peanut butter, and mix on medium until well incorporated. Scrape down the bowl, and mix in the eggs and vanilla extract.

2. In a medium bowl, combine the baking soda and flour. Slowly add to the butter mixture until well combined. Add the oats, and mix until well incorporated.

3. Remove the dough from the mixer, and hand mix the chocolate chips, peanut butter chips, and candy-coated chocolate.

4. Line a baking sheet with parchment paper. Using a ¼ cup measuring cup or large ice-cream scoop, scoop and drop cookies onto the baking sheet, placing them 2 inches apart. Flatten the tops of the cookies with a glass, and cover with plastic wrap. Place in the refrigerator, and chill for at least 4 hours.

5. Preheat the oven to 350°F.

6. Remove the cookies from the refrigerator and transfer to the oven. Bake for 20 minutes, rotating the baking sheet halfway through. When done, place the cookies on a wire rack to cool.

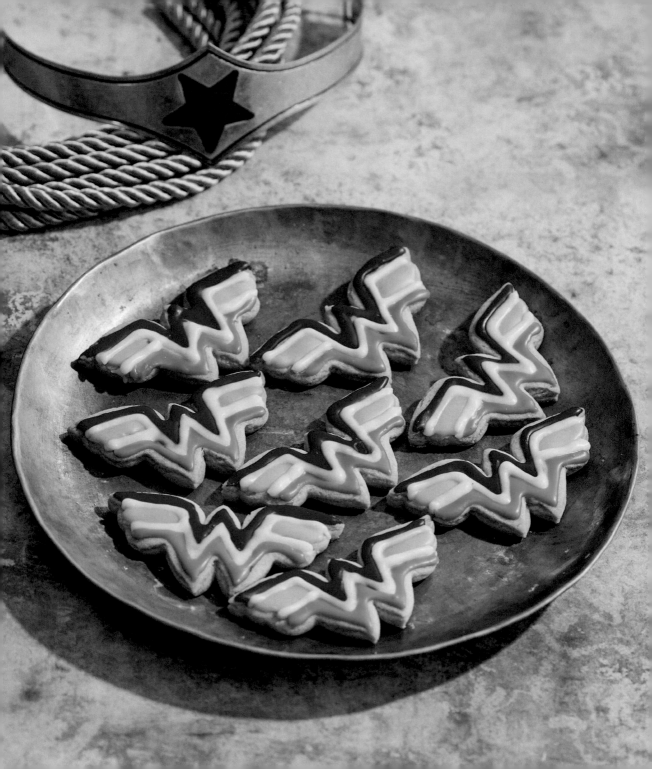

Wonder Woman Classic Iced Cookies

★ ★ ★ ★ ★ YIELD: 20 COOKIES ★ ★ ★ ★ ★

These classic iced cookies are shaped like Wonder Woman's logo and iced in red, gold, and blue. They're the perfect sweet treat for a birthday party, movie night, or any gathering of your favorite heroes.

FOR THE COOKIES:

½ cup unsalted butter, room temperature

½ cup sugar

1 teaspoon vanilla extract

1 egg, lightly beaten

1¼ cups all-purpose flour

½ teaspoon baking powder

½ teaspoon salt

FOR THE ICING:

2 cups powdered sugar

3 tablespoons heavy cream

1 tablespoon light corn syrup

½ teaspoon vanilla extract

Red, blue, and yellow food coloring

SPECIAL SUPPLIES:

Wonder Woman cookie cutter or a cookie cutter in your preferred shape

4 piping bags or resealable plastic bags

1. In the bowl of a stand mixer fitted with the whisk attachment at medium speed, beat together the butter and sugar until creamy. Add the vanilla extract and egg, and continue to mix until well combined.

2. In a medium bowl, combine the flour, baking powder, and salt. With the mixer on low, add the dry ingredients to the dough mixture, and mix until well combined.

3. Remove the dough from the mixer, and flatten it into a disc. Wrap with plastic wrap, and place in the refrigerator to chill for 1 hour.

4. Preheat the oven to 350°F. Prepare a baking sheet by lining it with parchment paper.

5. Remove the dough from the refrigerator, and place on a well-floured surface. Roll out to ¼-inch thickness. Using your Wonder Woman cookie cutter (or the cookie cutter of your choice), cut out the cookies.

6. Place the cookies on the prepared baking sheet about ½ inch apart, and bake for 8 to 10 minutes, or until cookies are a very light golden brown. Remove from the oven, and let cool completely on a wire rack before icing.

7. In a medium bowl, mix together the powdered sugar, cream, and corn syrup. Add the vanilla extract, and mix until well combined. If the icing is too thick to pipe, add more cream 1 teaspoon at a time.

Continued on page 104

8. Separate the icing evenly into four separate bowls. In one, add 2 to 3 drops of red food coloring (you can add more depending on how deep a red you'd like). In the second batch, add 2 to 3 drops of the blue food coloring (keep going a drop at a time if you'd like a darker blue). In the third batch, add 2 to 3 drops of the yellow food coloring until you reach a golden yellow. Do not color the remaining bowl of icing.

9. Add each of the icings to a piping bag or resealable plastic bag. If using a resealable plastic bag, cut one of the bottom corners so the icing can be squeezed out.

10. Decorate the cookies in red, gold, white, and blue, to match the Wonder Woman logo. Or go further and take your inspiration from Diana's costume, shield, or whatever else you like. Have fun with it!

Shield Cookies

Perfectly round butter cookies that resemble Diana's indestructible shield, these are made to celebrate victories both large and small on Themyscira.

½ cup unsalted butter

½ cup white sugar

¼ teaspoon salt

1 egg yolk

1 teaspoon vanilla extract

1 cup all-purpose flour

¼ cup pearled sugar

1. In a stand mixer fitted with the whisk attachment on medium speed, cream the butter with the white sugar and salt until the mixture is light and fluffy. With the mixer on low, add the egg yolk and vanilla extract, and mix until well incorporated. Slowly add the flour in two parts, and mix on low until just combined. Be careful not to overmix the dough.

2. Remove the dough from the mixer and roll into a log. Wrap the dough tightly in plastic wrap and chill in the refrigerator for at least 1 hour, or up to 2 days.

3. Preheat the oven to 350°F. Prepare a baking sheet by lining it with parchment paper and set aside.

4. Remove the dough from the refrigerator, and unwrap. Use a mortar and pestle (or a resealable plastic bag and rolling pin) to crush the pearl sugar into small pieces. Sprinkle the sugar on an unlined baking sheet, and roll the unwrapped dough into the sugar so the outside of the log picks up and is coated by the sugar. Slice the dough into 20 even rounds. Place cookies on the prepared baking sheet and bake for 10 minutes, or until lightly golden on the edges. Remove and let cool for a few minutes before serving.

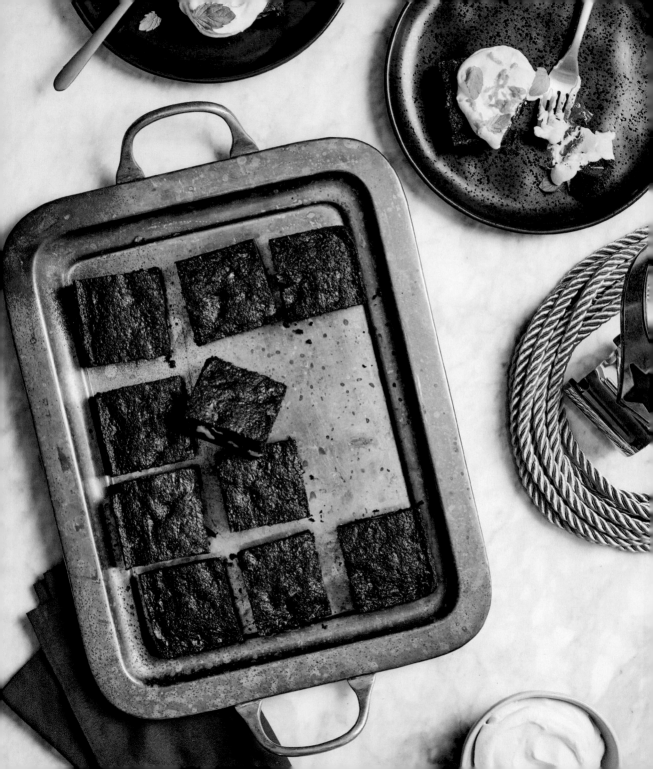

Diana's Dessert Bars

⭑ ⭑ ⭑ ⭑ ⭑ YIELD: 20 SERVINGS ⭑ ⭑ ⭑ ⭑ ⭑

Dark chocolate makes these brownie-like bars truly a sensation—just like their namesake Super Hero.

1 cup unsalted butter, room temperature

12 ounces dark chocolate, chopped

2 cups light brown sugar, tightly packed

3 teaspoons vanilla extract, divided

5 large eggs

¼ cup unsweetened cocoa powder

⅔ cup cake flour

1 teaspoon salt

½ cup walnuts, shelled and chopped

1 cup heavy cream

3 to 4 mint leaves, chopped, for garnish

1 orange, zested, for garnish

1. Preheat the oven to 350°F.

2. Heat 3 cups of water to a boil. Place a medium glass or metal bowl over the boiling water (or use a double-boiler if you have one), and melt the butter and chocolate together, stirring frequently until smooth. Remove from heat and let sit until cool to the touch.

3. In a large bowl, whisk together the brown sugar and 2 teaspoons vanilla extract. Whisk in the eggs, and beat until smooth and combined. Fold in the cooled chocolate until there are no streaks and everything is combined.

4. In a medium bowl, mix together the cocoa powder, flour, and salt. Slowly add the flour mixture to the chocolate mixture, and mix until smooth and combined (there should be no lumps). Stir the walnuts into the batter until evenly distributed.

5. Butter a 9-by-13-inch baking dish, and scrape the batter into the dish. Bake for 30 minutes, until a knife cleanly comes out of the center. Remove from the oven and let cool.

6. While the dessert bars are cooling, use an electric hand mixer on medium speed to whip the heavy cream and remaining 1 teaspoon vanilla extract until fluffy.

7. Slice the dessert bars, serve with whipped cream, and top with chopped mint and orange zest.

Peace Pudding

Though she is a fierce warrior, Wonder Woman's true role is as an emissary of peace to the world of mortals. While it's not always easy to bring humanity together, we can guarantee that this light but satisfying rice pudding will definitely bring people to your table.

2½ cups whole milk

⅓ cup short-grain white rice

3 tablespoons light brown sugar, tightly packed, or maple syrup

1 pinch salt

⅓ cup soft goat cheese

Cinnamon stick, dried figs, or honey, for garnish

1. Bring the milk to a simmer in a large pot over medium heat. Add the rice, brown sugar or maple syrup, and salt, stirring until the sugar has dissolved. Cook at a high simmer for about 30 to 35 minutes, or until the rice is tender. Be careful—do not let the mixture boil.

2. Remove from heat, and stir in goat cheese. Transfer to 4 bowls, and garnish with fresh grated cinnamon, dried figs, or honey.

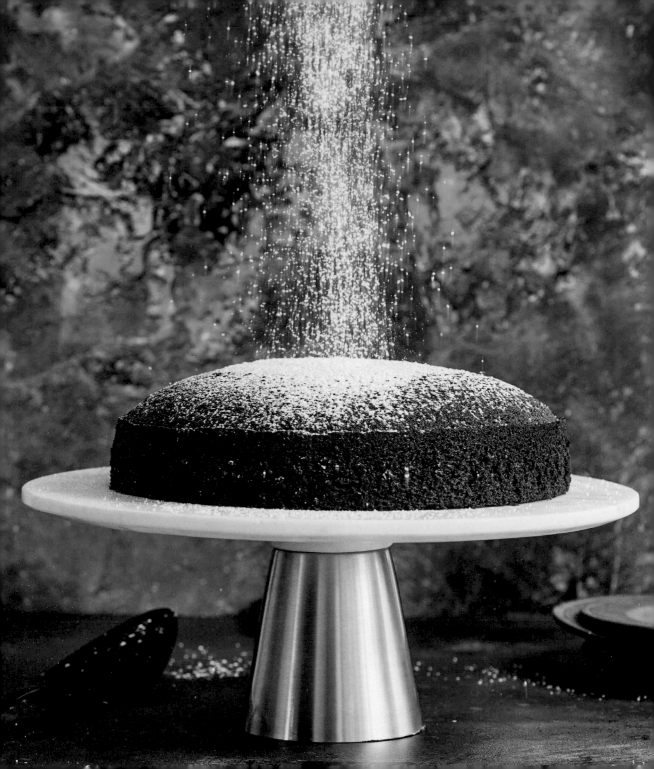

Artemis Ginger Cake

★ ★ ★ ★ ★ YIELD: 10 SERVINGS ★ ★ ★ ★ ★

The goddess of the hunt, the forests, the moon, and archery, Artemis is the patron goddess of the Amazons. Inspired by both her character and her vibrant red hair, this golden ginger cake has a complexity and depth that is the ideal balance of savory and sweet.

1 cup mild molasses

1 cup light brown sugar, tightly packed

2 eggs, lightly beaten

1 cup canola oil

1½ cups all-purpose flour

1 cup '00' Tipo flour

1 teaspoon ground cinnamon

½ teaspoon cardamom

1 cup water

1½ teaspoon baking soda

2 tablespoons ground ginger

Orange juice, for garnish

Powdered sugar, for garnish

1. Preheat the oven to 350°F. Line the bottom of a 9-inch round cake pan with parchment paper, and set aside.

2. Combine the molasses, brown sugar, eggs, and oil in a large bowl. In a separate medium bowl, combine the flours, cinnamon, and cardamom.

3. Add the water to a medium saucepan over high heat, and bring to a rolling boil. Add the baking soda, molasses mixture, and ginger, stirring frequently until everything dissolves. Turn the heat down to low, and whisk in the flour mixture until everything is combined.

4. Pour the batter into the cake pan, and bake for 1 hour or until a knife or cake tester comes out clean when inserted into the center. Let cool until it is just warm, and drizzle with fresh-squeezed orange juice. When the cake has reached room temperature, sprinkle with powdered sugar.

TIP:
THIS CAKE GOES GREAT WITH CREAM CHEESE FROSTING. IF USING, SKIP THE ORANGE JUICE DRIZZLE AND LET THE CAKE COOL TO ROOM TEMPERATURE BEFORE FROSTING. YOU CAN SPEED UP THIS PROCESS BY PLACING IT IN THE REFRIGERATOR.

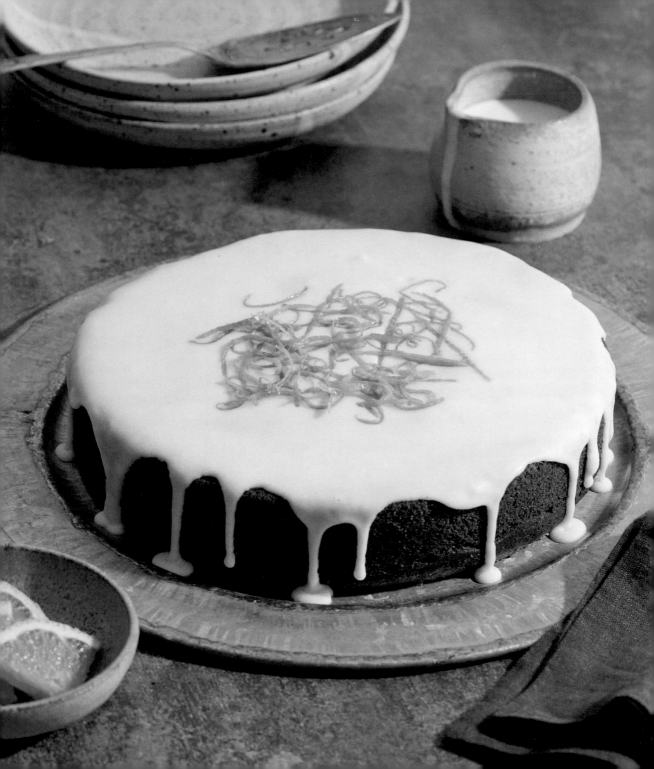

Legendary Olive Oil Cake With Orange Glaze

★ ★ ★ ★ ★ YIELD: 8 SERVINGS ★ ★ ★ ★ ★

Bursting with fresh orange flavors, this moist, luscious olive oil cake is soon to be as legendary as Wonder Woman herself. It makes a delectable addition to your after-dinner or brunch arsenal.

FOR THE CAKE:

2 cups cake flour or all-purpose flour

⅓ cup cornmeal

2 teaspoons baking powder

½ teaspoon baking soda

1 teaspoon salt

¼ cup fresh-squeezed orange juice

2 teaspoons vanilla extract

3 large eggs

1 tablespoon orange zest

1 cup light brown sugar, tightly packed

1¼ cups extra-virgin olive oil

FOR THE GLAZE:

½ cup fresh-squeezed orange juice

3 tablespoons powdered sugar

1. Preheat the oven to 375°F.

2. Lightly oil the bottom and sides of a springform pan. (If you don't have one, a 9-inch baking pan will do; it will just be harder to remove the cake after baking.)

3. In a large bowl, whisk together the flour, cornmeal, baking powder, baking soda, and salt. In a separate bowl, stir together the orange juice and vanilla extract.

4. With an electric mixer on high speed, whisk together the eggs, orange zest, and brown sugar until the whole mixture is light and fluffy (there should be no clumps), 3 to 5 minutes.

5. While continuing to mix on high, slowly pour the extra-virgin olive oil into the egg mixture. When that is combined, reduce the mixer speed to low, and add a third of the flour mixture, followed by half the orange juice mixture. Repeat this, adding another third of the flour mixture, followed by the rest of the orange juice mixture, followed by the rest of the flour mixture. Continue mixing until everything is well combined.

6. Scrape the batter into the oiled baking pan. Place the cake in the oven, and bake until the top is golden brown and a cake tester or a toothpick in the center comes out clean, about 50 minutes. Transfer to a wire rack to cool.

7. While the cake is cooling, make the glaze by mixing together the fresh-squeezed orange juice and powdered sugar. Once the cake has cooled to just warm, remove cake from pan and drizzle the glaze on top. Serve immediately.

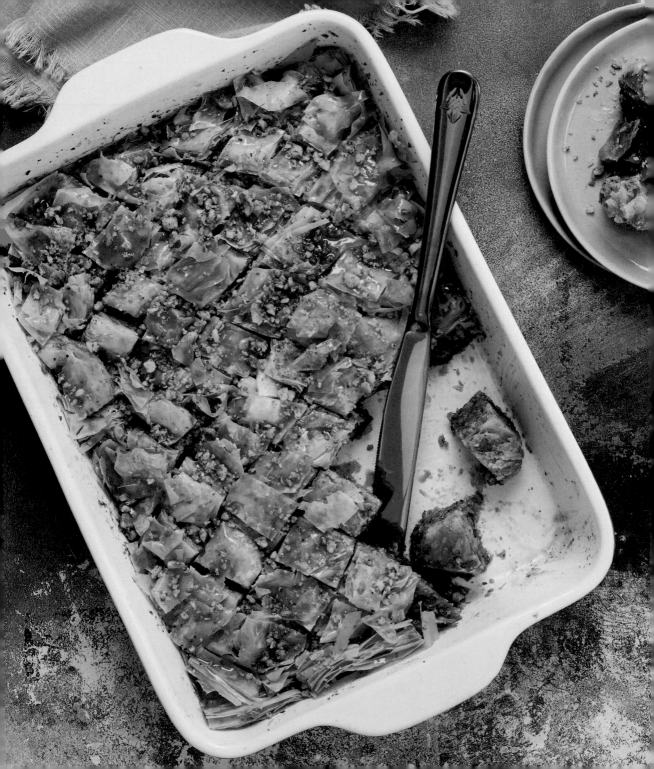

Baklava of Themyscira

While the Amazons of Themyscira probably make their phyllo from scratch, those of us who live in the mortal world don't usually have the time. Using store-bought phyllo sheets makes assembling this traditional Mediterranean dessert quick and easy. It's sure to become an immortal favorite for you and your family.

FOR THE BAKLAVA:

1 package frozen phyllo dough, thawed

1 pound walnuts, shelled

1½ teaspoons cinnamon

½ teaspoon ground cardamom

¼ teaspoon salt

1 cup butter, melted

FOR THE SYRUP:

1 cup water

1 cup light brown sugar, tightly packed

½ cup honey

2 tablespoons fresh-squeezed lemon juice

2 tablespoons fresh-squeezed orange juice

1 cinnamon stick

1. Preheat the oven to 350°F.

2. Lightly butter a 9-by-13-inch baking dish, and set aside.

3. Unroll the phyllo dough, and trim all layers to fit the pan. Cover with a damp paper towel.

4. In a food processor, combine the walnuts, cinnamon, cardamom, and salt, and process until the walnuts are just chopped. Be careful not to overprocess; you want chunks, not a finely ground powder.

5. Place a sheet of the phyllo dough into the pan. Brush with the melted butter.

6. Spoon a thin layer of nut mixture onto the sheet of phyllo. Add 2 more layers of phyllo on top, brushing each one with butter. Repeat this process 7 more times, ending with 5 layers of buttered phyllo on top.

7. Bake for 35 minutes, until the edges are golden. Cut into 20 equal pieces, and let cool slightly.

8. While the baklava is cooling, make the syrup.

9. In a medium saucepan, heat the water, brown sugar, and honey, stirring until the sugar and honey have fully combined. Add the lemon juice, orange juice, and cinnamon stick, and cook on low heat for 10 minutes.

10. Take the syrup off the heat, and let it cool and thicken, about 10 minutes. Discard cinnamon stick, spoon the syrup over the baklava, and let cool in the refrigerator for at least 1 hour.

Faster than Diana
No-Bake Lemon Custard

★ ★ ★ ★ ★ YIELD: 4 SERVINGS ★ ★ ★ ★ ★

High on flavor but low on work, this creamy golden custard comes together faster than Diana can do the hundred-yard dash—no time in the oven needed!

1½ cups heavy cream

½ cup sugar

2 teaspoons lemon zest

1 teaspoon orange zest

½ cup lemon juice

Salt

Honey, for garnish

Fresh mint, for garnish

1. In a saucepan, heat the cream, sugar, and zests on medium until the sugar is dissolved. Let the mixture thicken, cooking for about 4 more minutes.

2. Turn off the heat, and stir in the lemon juice and salt to taste. Let it sit until the mixture is at room temperature. Run the mixture through a cheesecloth or fine strainer. Place the mixture in the fridge, and chill for at least 2 hours.

3. When ready to serve, place in individual containers, and top with a drizzle of honey and sprigs of fresh mint.

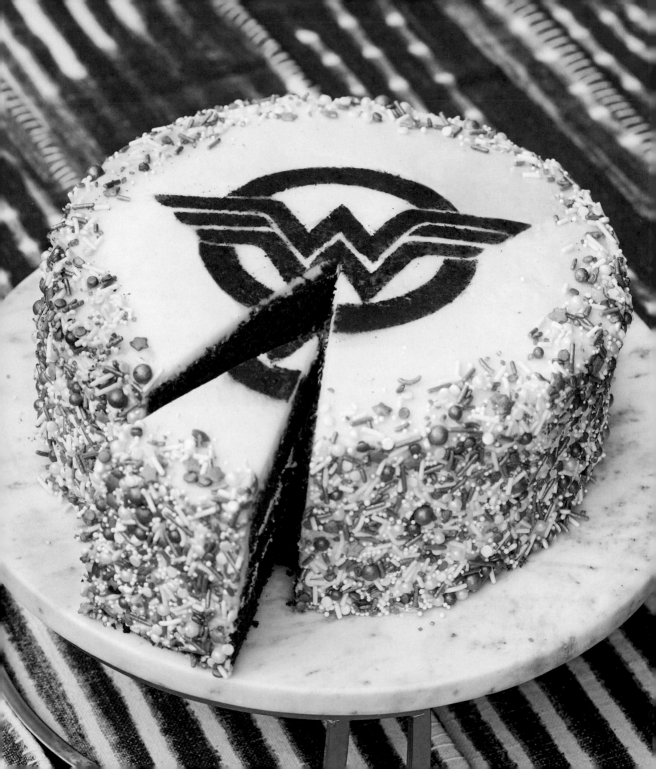

Victory Cake

★ ★ ★ ★ ★ YIELD: 8 SERVINGS ★ ★ ★ ★ ★

The perfect centerpiece for any Wonder Woman—themed party or event, this red velvet cake, topped with cream cheese frosting and glittering with shiny gold sprinkles, is an absolute winner.

FOR THE CAKE:

¾ cup unsalted butter, room temperature, plus more for pans

3 cups cake flour, plus more for pans

2 cups sugar

2 eggs, room temperature

2 teaspoons vanilla extract

3 tablespoons cocoa powder

2 tablespoons red food coloring

1 teaspoon salt

1 tablespoon baking powder

1 teaspoon baking soda

1½ cups buttermilk

1 tablespoon white vinegar

FOR THE FROSTING:

½ cup unsalted butter, room temperature

8 ounces cream cheese

2½ cups powdered sugar

1½ teaspoons vanilla extract

1. Preheat the oven to 350°F. Grease and flour three round 9-inch baking pans. Tap out any excess flour.

2. In a stand mixer fitted with the paddle attachment, or using a hand mixer on medium, cream together the butter and sugar until light and fluffy. Add one egg at a time and beat well to combine. Add the vanilla extract, and beat until well incorporated.

3. In a small bowl, combine the cocoa powder and red food coloring. Pour into the batter, and mix until the batter is a deep red with no streaks.

4. In a medium bowl, combine the flour, salt, baking powder, and baking soda. Add a third of the flour mixture to the batter, stirring until well combined, followed by half of the buttermilk. Continue to alternate adding the flour mixture and buttermilk to the batter, ensuring each batch is well incorporated before adding more. Add the vinegar, and mix until well incorporated.

5. Divide the batter evenly into the three prepared pans. Tap them firmly on the counter to remove any air bubbles.

6. Bake the cakes for 25 to 30 minutes, until a knife can be inserted in the middle and comes out clean. Remove from the oven, and let cool to room temperature in the pans.

7. While the cake is cooling, make the frosting. In a medium bowl, mix together the butter and cream cheese until smooth. Slowly beat in the powdered sugar and vanilla extract until all ingredients are well combined.

Continued on page 120

FOR DECORATION:

Sprinkles in white and gold, for decorating

Red edible luster dust, for decorating

TO ASSEMBLE YOUR CAKE:

8. Remove the cakes from their pans and ensure they are completely cooled. Place the first layer onto your serving tray, and cover with a quarter of the frosting. Repeat with the next layer. After the final layer is placed on top, use the rest of the frosting to cover the top and sides of the cake.

9. Spoon white and gold sprinkles over the sides and around the top rim of the cake. Use gloved hands to push extra sprinkles into any gaps so that the entire side of the cake is covered. Transfer the cake to the fridge to chill until frosting is stiff, at least 20 minutes.

10. Print Wonder Woman stencil out on card stock and use an X-Acto knife to cut it out.

11. Remove cold cake from fridge. Pour decorating dust into a mesh sieve. Gently lay stencil on top of the cold cake and dust over stencil with decorating dust. Carefully lift stencil away. Serve on a marble platter in the center of your buffet table.

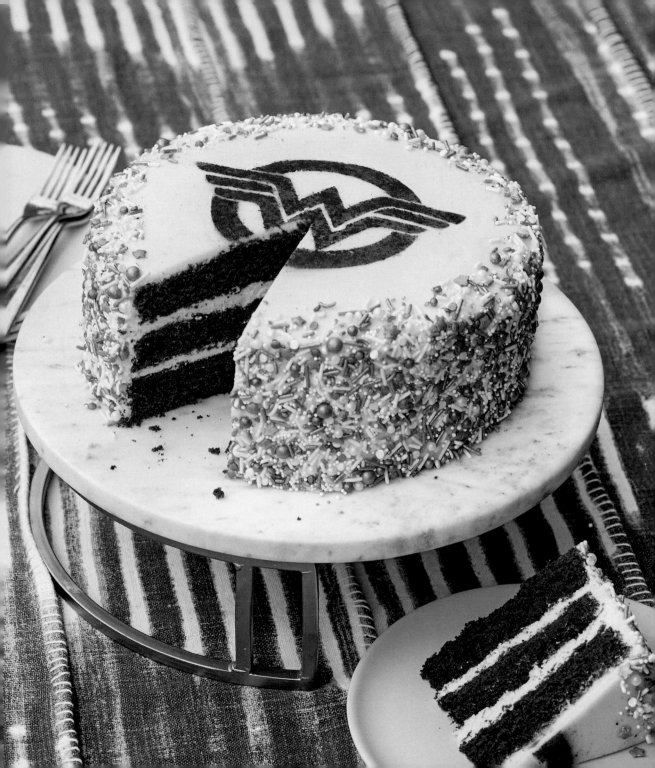

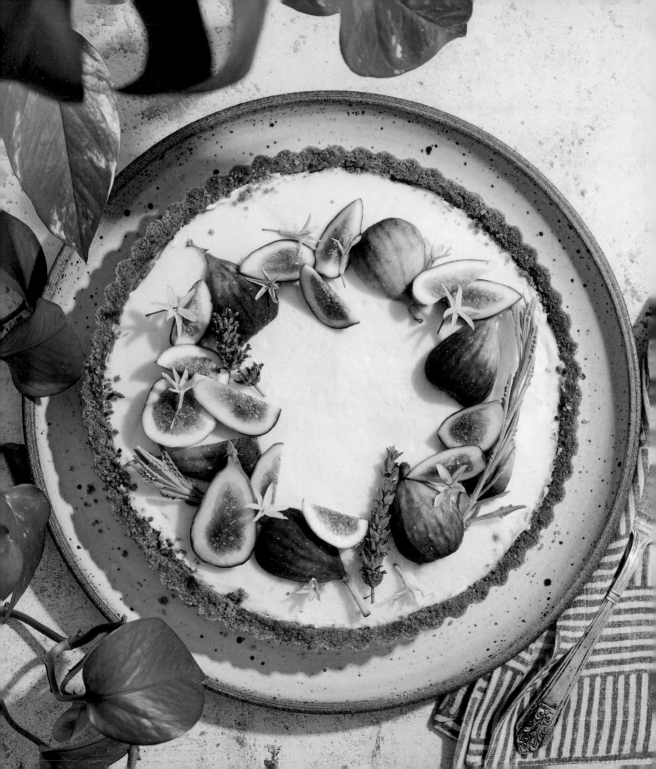

Amazon Treasure Fig and Cream Cheese Cake

YIELD: 8 SERVINGS

Featuring a graham cracker crust and a honey, rosemary, and fig drizzle, this cake is a treasure worth fighting for. Try to remember to follow the tenets of the Amazons . . . and share with your sisters!

FOR THE CRUST:

1 cup finely crushed graham crackers

2 tablespoons light brown sugar, packed

¼ teaspoon kosher salt

½ cup unsalted butter, melted

FOR THE FILLING:

16 ounces cream cheese, room temperature

¾ cup sugar

¼ teaspoon salt

1 teaspoon vanilla extract

½ cup sour cream

½ teaspoon grated orange zest

2 eggs, room temperature

1 egg yolk, room temperature

1. Preheat the oven to 350°F. Line the bottom of a 9-inch springform pan with waxed paper.

2. To make the crust: In a bowl, mix the graham crackers, sugar, salt, and melted butter until well combined. Press the mixture into the bottom and about halfway up the sides of the springform pan to create an even crust for the cake. Bake crust until fragrant, about 10 to 12 minutes. Remove and cool.

3. To make the cream cheese filling: In a food processor, pulse the cream cheese, sugar, salt, and vanilla extract until smooth, scraping down the sides as necessary. Add the sour cream and orange zest, and pulse again until smooth. Add eggs and yolk, and pulse until filling just comes together.

4. Pour the filling into the crust once the crust is cool. Bake the cake until its edges are set but its center is still wobbly, about 35 to 40 minutes. Cool in the pan on a wire rack. Chill for at least 3 hours, or up to 3 days ahead.

Continued on page 124

FOR THE HONEY AND FIG DRIZZLE:

½ cup honey

1 cup chopped figs

Pinch of salt

1 tablespoon picked and chopped fresh rosemary

5. To make the honey and fig drizzle: In a saucepan, combine honey, figs, ½ cup water, and pinch of salt. Bring to a simmer over medium heat, stirring occasionally, until thickened, about 5 minutes. Add the rosemary, and simmer for another 2 minutes. Let cool for at least 5 minutes. If desired, purée in a blender until smooth. This can be kept in a refrigerator for up to 3 days ahead of serving.

6. When ready to serve, bring the cake to room temperature. Gently warm the honey and fig syrup on the stove in a pot over medium heat. Run a knife around the edges of the cake and unmold from the springform pan. Slice and serve, using a spoon to drizzle fig syrup over each slice.

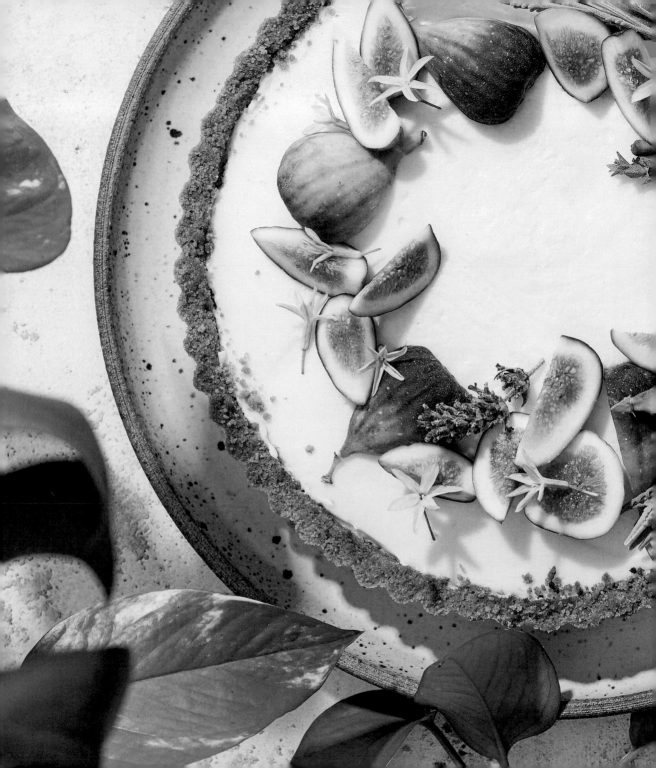

PARTY
Time

· · · · · · · ·

Let's get this party started! With so many tasty and timeless recipes in this book, you have limitless options to throw the biggest hero's bash of the year. The following are a few recipes that go well together and can help inspire your next birthday party, movie night, or brunch with your favorite Amazonians. Enjoy!

A Superhero Birthday Bash

★ ★ ★ ★ ★ ★ ★ ★ ★ ★

Superheroes big and small deserve a huge bash to celebrate another year around the sun. You can't have a Wonder Woman—worthy party without a Paradise Island—style feast. Whether your celebration is a big party or a more intimate gathering, this is the perfect menu for an unforgettable birthday bash.

TO START

Goddess Goodies (page 47)

Paradise Platter (page 39) served with Greek Goddess Dressing (page 54), The Cheetah Chickpea Spread (page 60), and/or The Dip of Strength and Power (page 55)

MAIN DISH

Gift of the Gods Salad (page 41)

Justice League Lasagna (page 89)

FOR DESSERT

Victory Cake (page 119)

Wonder Woman Classic Iced Cookies (page 103)

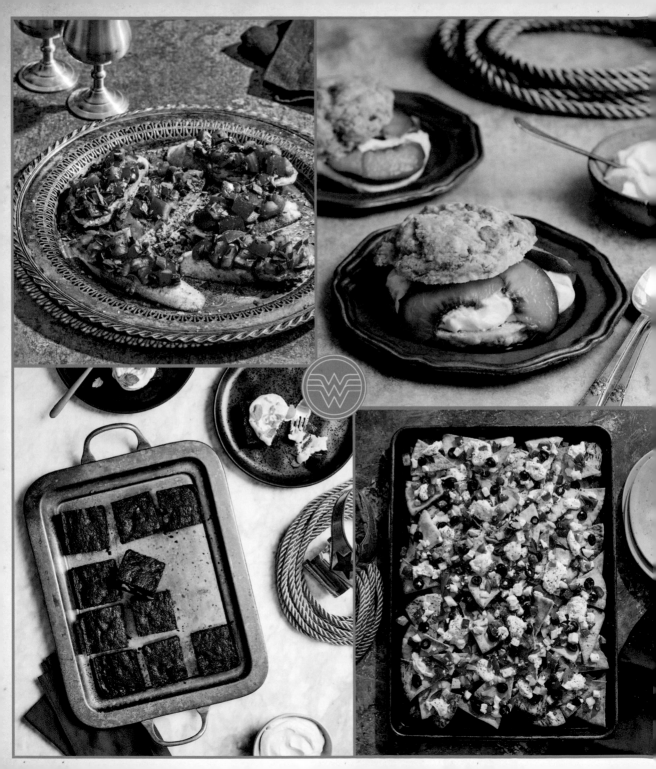

Movie Night

★ ★ ★ ★ ★ ★ ★ ★ ★ ★

Bringing your team together to watch your favorite warrior from Themyscira on the silver screen? Then treat them to a hero's welcome with snacks and treats that will keep everyone going through even the longest superhero movie marathon. Movie night just got epic.

SNACKS AND APPS

Tomato and Greek Olive Swords (page 57)

Feed the League Nachos (page 71)

The Dip of Strength and Power (page 55)

SWEET TREATS

Diana's Dessert Bars (page 107)

Golden Lasso Peach Shortcake (page 97)

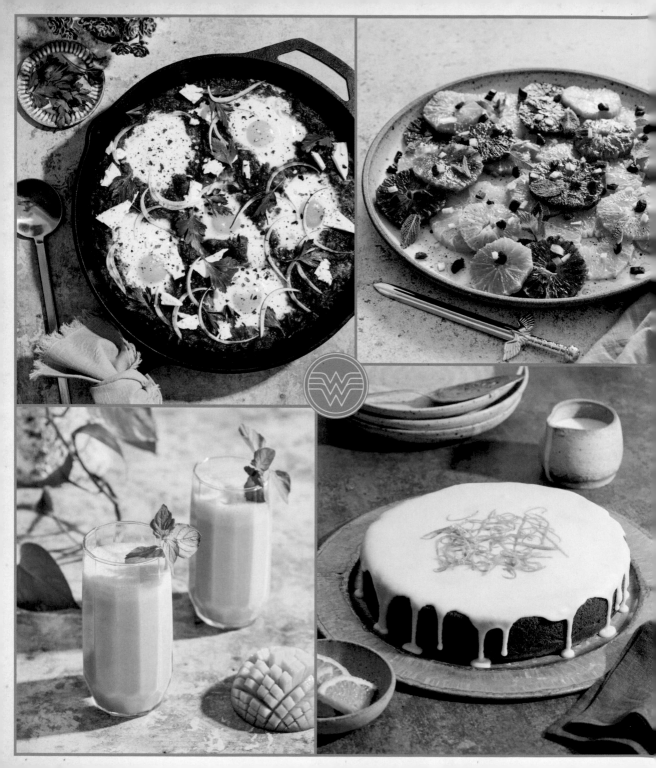

Weekend Warrior Brunch

★ ★ ★ ★ ★ ★ ★ ★ ★ ★

Whether you're a superhero who fights crime or one who takes care of your family, brunch is definitely the best meal of the week. Start your weekend like an Amazon as you build a warrior-worthy brunch to rival the tastiest breakfast on Themyscira.

MAIN DISH

Cassandra Sandsmark's Shakshuka (page 21)

ON THE SIDE

Fruit of the Gods Muffins (page 27)

Winter Wonder Fruit Salad (page 45)

TO DRINK

Mango Lassi of Truth (page 99)

FOR DESSERT

Legendary Olive Oil Cake With Orange Glaze (page 113)